to our favorite
Wild
Woman of
Wyoming,
Chris &
SUE ☮

merry
Christmas
'18

WILD WOMEN of MICHIGAN

WILD WOMEN of MICHIGAN

MICHIGAN

A HISTORY OF SPUNK AND TENACITY

NORMA LEWIS

THE
History
PRESS

Published by The History Press
Charleston, SC
www.historypress.net

First published 2017

Manufactured in the United States

ISBN 9781467137690

Library of Congress Control Number: 2017940943

For David, Rhonda, Pat, Shelby and Shane, with love

CONTENTS

ACKNOWLEDGEMENTS

The first thank-you rightly goes to Julie Tabberer, Jennifer Payette Andrew and the staff at the Local History Department of the Grand Rapids Public Library, including Ruth Van Stee, now retired, who has always shown enthusiasm for my projects and for this one directed me to Elizabeth Eaglesfield. This library has an amazing collection of Grand Rapids and Michigan history conveniently housed in one space. You all have patiently answered my questions, steered me in directions I would not have thought of on my own and in so many other ways made this a really fun project. So many times, with your help, I found something better than what I thought I was looking for.

I can't say enough good things about the Library of Congress and the Bentley Historical Library of the University of Michigan in Ann Arbor. Thank you for assembling your fantastic collections and your generosity in making them available to the public. You have extensive collections and user-friendly digital databases on which to find specific subjects as well as simply browsing to see what might show up.

Thanks, too, to Angela Reidel at the Michigan Women's Hall of Fame–Lansing for locating images. What fun to browse your gallery of the women who had a hand in making Michigan the great state it is today. Other sources of images in this book are Nathan Kelber of the Detroit Historical Society, Brien Boyea at the Racing Hall of Fame, Wikimedia Commons, Janelle Martin at the Lapeer District Library, Loutit District Library, Benton Harbor Library and Solweig Hommema at the Bissell Home Care Company.

ACKNOWLEDGEMENTS

As always, I'm deeply indebted to the great folks at Arcadia/The History Press. First to Krista Slavicek, with whom I started this journey, and to Candice Lawrence, who made the transition seamless following Krista's departure. Thanks, too, to Hilary Parrish for her great copyediting skills during the final process and to Natasha Walsh for a terrific cover. Another huge thank-you goes to all of you behind-the-scenes people at The History Press for making the finished product a book to be proud of. That includes Magan Thomas and the marketing team that does such an awesome job of publicizing the books you publish.

Last, but never least, thank you to my granddaughter, Shelby Ayers, for her assistance. I couldn't do it without you, Sweetie. Also, thanks to all my family and friends who keep me energized—not always an easy task.

INTRODUCTION

Of all the wild beasts of land or sea, the wildest is woman.
—*Menander (342?–291? BC)*

Has that changed since Menander wrote those words so long ago? Let's hope the women found in these pages are proof that at least in Michigan, feistiness, boldness, wildness or whatever we choose to call it is still alive and well.

Michigan women's achievements reach far beyond the state's borders. In entertainment and sports alone, look at Madonna Louise Ciccone (aka Madonna), the Supremes, Gilda Radner, Gillian Anderson, Ellyn Burstyn, Julie Harris and blues great Sippie Wallace. Detroit was the birthplace of the Motown sound, bringing the city fame and fortune. Let's not forget sports legends Marion Ladewig, Julie Krone and Serena and Venus Williams.

Those are names we all know. In these pages, you will also meet some of the lesser-known women in history who pioneered change and expanded women's roles in the state and beyond. Some of their actions made them seem wild during the times in which they lived, but most were more feisty than actually wild. These ordinary women rose above their circumstances to live extraordinary lives. You will find some notable exceptions—a few who would be considered wild at any time, along with a smattering of blatant scofflaws.

Madame LaFramboise, the wife of a French fur trader, worked alongside her husband and took over his trading post on the Grand River after his

death. Not only was she a woman but an Ottawa Indian as well. Pauline Cushman defied her parents and became an actress, a profession that no doubt came in handy in her offstage role of Civil War spy.

There were, of course, the usual rabble-rousers in the form of abolitionists, temperance workers, union agitators and suffragettes. Some of the latter didn't just want to vote; they wanted women to be voted for. Early officeholders blazed the trail for former governor Jennifer Granholm, former and current Michigan secretaries of state Terri Lynn Land and Ruth Johnson and United States senator Debbie Stabenow. Candice Miller served first as secretary of state and, in the 1998 election, won in every county, beating her opponents by a million votes, the largest margin of any candidate in a state election. She went on to represent Michigan's Tenth District in the United States House of Representatives.

What would a book about wild women be without a few criminals and, arguably, the wildest of the wild, the soiled doves? Michigan had and still has its fair share of both.

Chapter 1

THOSE GUTSY PIONEERS AND THE NATIVE WOMEN WHO WELCOMED THEM

The dogma of woman's complete historical subjugation to man must be rated as one of the most fantastic myths ever created by the human mind.
—*Mary Ritter Beard, 1946*

It wasn't easy to be wild back in the territory's earliest days, but neither was it impossible. Though men definitely sat in the catbird seat, their wives found subtle ways to rebel. Like Elizabeth Babcock. When her husband forbade her to bring her good china to Michigan, Elizabeth hid it in flour barrels. That "Me Tarzan, you Jane" attitude still prevailed in 1921 when, to their shame, Michigan Supreme Court justices ruled that a man is the master of his wife whenever he is home. No wonder those ladies rebelled. Can't you see them breaking into a happy dance each time the door closed behind their lord and master?

Marie-Therese Guyon Cadillac

The French Guyon family had settled in Quebec in 1634, when Quebec was called New France. Marie-Therese was born to Denis and Elizabeth Guyon in 1671. Her mother was distantly related to French royalty. That was meaningless to young Marie-Therese, whose childhood experiences in the fur-trading community imbued her with a business sense that helped

greatly when she found herself in Fort Ponchartrain. She had grown up playing with children of the Algonquin, Huron and Iroquois tribes, enabling her to move easily among Michigan's tribes without fear or prejudice.

Madame Marie-Therese Guyon Cadillac and her traveling companion, Anne Picote de Bellestre, were the first two white women to arrive in the settlement of Fort Ponchartrain du De Troit. With them was Cadillac's thirteen-year-old son. The party arrived in May 1702. Both women came from Montreal, Quebec, to join their husbands. Cadillac was married to Antoine de la Mothe Cadillac, commander of the fort. Bellestre's husband was his first lieutenant. The native tribeswomen greeted them with great excitement and said they were the first French women they had ever seen. Also on hand to greet the party was Cadillac's nine-year-old son, who had accompanied his father. She also had two daughters, but they had remained in Canada and later joined the family.

Antoine Cadillac had ties to French aristocracy. His family coat of arms would later grace the Cadillac automobile. He also had an abundance of blind ambition that had led to his being transferred from a spot near present-day St. Ignace to this new post at Fort Ponchartrain du De Troit, located in the straits between Lake Huron and Lake Erie. *Le detroit* is French for "the strait."

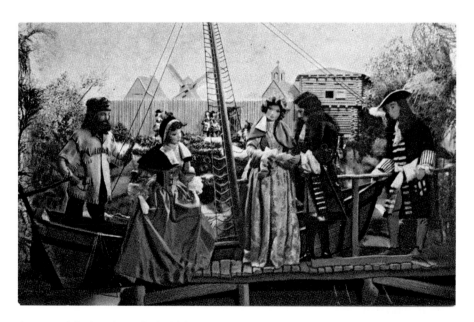

A postcard depicts the arrival of Madame Cadillac in what is now Detroit. *Detroit Historical Society.*

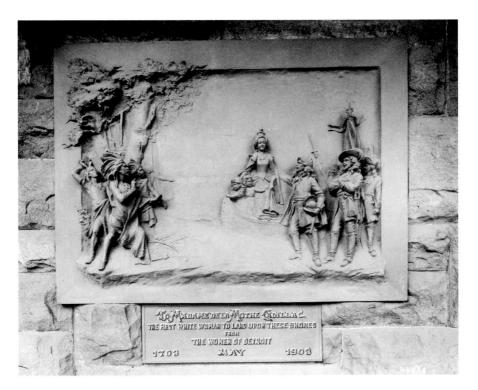

The plaque in the Detroit Art Museum reads, "To Madam de la Mothe Cadillac, the first white woman to land upon these shores from the women of Detroit." *Library of Congress.*

Marie-Therese Cadillac and Anne Picote de Bellestre were already close friends, having met during their days at a strict boarding school operated by nuns at the Ursuline monastery in Quebec City. There they learned the arts needed by society girls of their time: home management skills, needlework, art, music, comportment and social graces. Now their lives had again intertwined as they set out to settle in and bring a much-needed touch of female refinement to an unimaginable wilderness. Their incredible journey had begun eight months earlier, when they climbed into one of the twenty-five canoes making the trip and traveled 750 miles through hostile Iroquois Indian territory. Both women took their turns paddling across Lake Ontario, then called Lake Frontenac. They had portaged around Niagara Falls.

Cadillac's friends tried in vain to dissuade her. She replied, "Do not waste your pity on me, dear friends. I know the hardships of the journey, the isolation of the life to which I am going; yet I am eager to go, for to a woman who truly loves her husband there is no stronger attachment than his company wherever he may go."

The reality was beyond anything either woman could have imagined. Because the fort had no doctor, ministering to the sick fell to Cadillac, who was assisted by Bellestre. They drew on remedies the nuns had used and also those they had learned from their native neighbors back in Canada. The latter involved growing herbs and turning them into potions and poultices.

While living in Fort Ponchartrain, Marie-Therese and Antoine had more children, bringing the final count to thirteen, seven of whom lived to adulthood. In addition to caring for an ever-growing family and serving as medicine woman, Marie-Therese helped Antoine in his business dealings, filled in for him when his travels took him away and arranged schooling for both the white and native children. It could be argued that had it not been for her tireless devotion to her duties in those early days, a city other than Detroit might have become Michigan's largest. She has been described as pious, intelligent, business smart and possessing an outstanding devotion to humanity. No doubt those sterling character traits were called upon repeatedly in her time at the fort.

Eventually, Antoine fell out of favor with the powers that be and was assigned to a lesser Louisiana post. Following that, the family was sent to France, where Antoine died in 1736 at age seventy-eight. Marie-Therese died ten years later. She was seventy-five.

MADAME MAGDALAINE LAFRAMBOISE

Madame LaFramboise wasn't a pioneer. As an Ottawa Indian, she was already on hand to meet new arrivals. One of those newcomers was Joseph LaFramboise, a member of a prominent French trading family. He first came to her village when she was fifteen and quickly fell in love with the beautiful Indian maiden.

Mackinac Island's rich history begins with the Indians who first inhabited it. Magdalaine's tribe, the Odawa (Otttawa), were first called the Algonkins and lived on and near the St. Lawrence River area. The Iroquois eventually drove them to the Michilmackinac area. The first white man to explore the region was Jean Nicolet in the early 1600s. That and the burgeoning fur trade cemented the ties between the French and the Ottawa.

The lives of the French Canadians and natives had become intermingled over the years, and Magdalaine, born in 1780, was the daughter of another French fur trader, Jean Baptiste Marcot, and his Ottawa wife,

Marie Nekesh. Though there are no images of her, history reports she was beautiful, having inherited the best of both parents: natural good looks coupled with French elegance.

One thing they had in common was unwavering Catholicism. Joseph's devotion to the faith was said to be second only to that of ordained priests. The two married when she was sixteen in an Indian ceremony but were later remarried by a Catholic missionary. A year later, Magdalaine bore her first child, a daughter she named Josette in honor of her beloved husband. Joseph took his wife and daughter with him when he visited and conducted business with the various tribes in the Michigan forests. Magdalaine proved a valuable partner, for though she was unable to read, she spoke four languages: English, French, Ottawa and Ojibwe. They traveled through what is now Michigan with a servant or two and a dozen or so oarsmen, called *voyageurs*, navigating two pelt-filled boats through the scenic waterways. Once the business had been completed, the LaFramboise family returned to Mackinac Island, where they spent their summers.

This idyllic family life came to an abrupt end in 1809, when an Indian named White Ox, believing falsely that he had been cheated, killed Joseph. Indians in another village eventually caught Joseph's killer and delivered him to LaFramboise so she could have her pound of flesh. Tempting though that must have been, her abiding Catholicism required her to forgive him. The rest of the village was less pious, and though his life was spared, he lived the rest of his life as a social pariah. White Ox was dealt with in the Ottawa version of an Amish shunning.

Her husband's death pushed LaFramboise deeper into the family's prosperous business, as she was then forced to take over Joseph's responsibilities while still caring for her young family, which by then included a son, Joseph. It was a logical choice, as her options were limited. She had learned the fur business from her husband and, before that, her father, so despite having no formal education, she had an innate business sense.

By all accounts, she did an outstanding job. She traveled the territory and was well known and respected in the Grand River Valley. Her fluency in four languages made it possible to negotiate with her diverse clientele in their own languages, an advantage most other traders lacked. Her trading post was on the river east of Grand Rapids in what is now the village of Ada. One way she cemented her relationship with the natives was by extending them credit when no one else was willing to take the risk. That way, the trappers could obtain what they needed for their winter's work and pay her in pelts come spring.

Another step she took had to have tugged at her conscience a bit, but she felt it necessary. Though providing liquor to the natives was forbidden by her church and frowned upon by most, rightly or wrongly, LaFramboise sidestepped the issue by offering a watered-down, tobacco- and herb-enhanced, less intoxicating product. Most trappers refused to negotiate with a trader without first obtaining some firewater. Responding to those demands was the only way she could have remained in business. This was affirmed by Potawatomi chief Topenebee's statement to Indian agent Lewis Cass in 1821: "Father, we care not for the land, or the money, or the goods; what we want is whiskey."

Among her competitors, the biggest, the American Fur Company, was owned by the wealthy Astor family of New York. When the Michigan Astor representative proved unable to steal her business, they took her into the company, where she worked until retirement.

LaFramboise earned the respect of all for her business savvy and integrity. She flourished and eventually became wealthy enough to send her children to the best schools in Montreal. She knew the phenomenal success she had achieved without an education had been a fluke and wanted to make sure all children had every advantage.

When Josette, her firstborn, married fort commander Captain Benjamin Pierce, whose brother was future president Franklin Pierce, it was a social highlight to remember. Benjamin's military colleagues wore full dress uniforms, while female guests sparkled in the latest fashion. But with the exception of the bride, LaFramboise was the showstopper. She wore a deerskin dress that in its simple elegance showcased the intricately beaded designs that were further enhanced with porcupine quills. It was a work of art.

Josette died of childbirth complications on November 24, 1820, a few days after giving birth to her second child, Benjamin Langdon. The infant also died. Her first child was a girl, Josette Harriet. Had Josette lived until his inauguration on March 4, 1853, the daughter of an Ottawa Indian mother and French Canadian fur trader would have been a sister-in-law of the president of the United States. The Pierce family's presidential association didn't end with Franklin. Barbara Pierce Bush, wife of the forty-first president and mother of the forty-third, was Franklin Pierce's direct descendant.

LaFramboise sold her business to Rix Robinson and moved permanently to Mackinac Island in 1821. Robinson was an Astor agent who, among his other accomplishments, founded the city of Grand Haven along with Presbyterian Reverend William Montague Ferry.

Right: A postcard shows an artist's rendering of the fort at Mackinac, with the bridge to Mackinac Island in the distance. *Author's collection.*

Below: Picturesque Mackinac Island is where Magdalaine LaFramboise summered before returning permanently in retirement. *Library of Congress.*

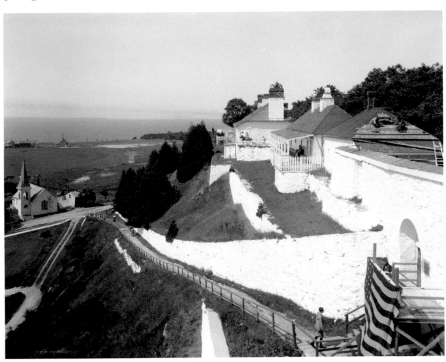

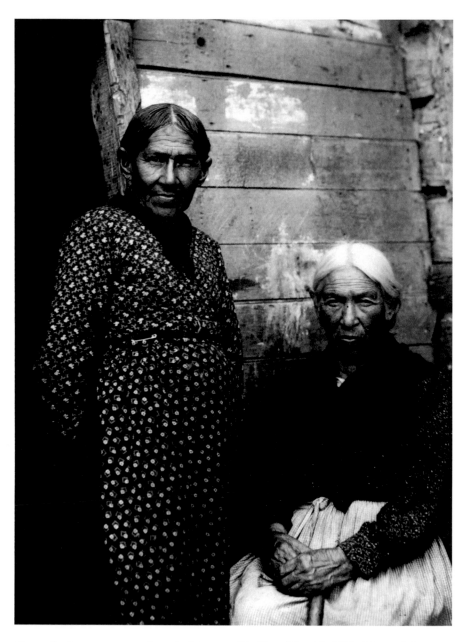

Ottawa Indian women pose in typical dress on Mackinac Island in 1903. *Library of Congress.*

Back home on Mackinac Island, Magdalaine worked hard in the local Catholic St. Anne's Parish, even to the extent of keeping the congregation going during a few years when there were no priests. She is also remembered for training young Ottawa women to become schoolteachers. She wanted to make sure that Ottawa children whose families could not afford to send them to faraway schools, as she had done, also received an education that would permit them to find employment. When the church had to be moved, LaFramboise donated the property next to her house, asking only that she be buried under the altar at her beloved St. Anne's. Before her death in 1846 at age sixty-six, LaFramboise made time to learn to read French and English, languages she had long spoken.

Jane Johnston Schoolcraft

Thirty-seven years before Michigan became a state, Jane Johnston was born in 1800 in Sault Ste. Marie. Her Ojibwe mother Susan's Indian name was Ozhaguscodawayquay, meaning Woman of the Green Valley. She was the daughter of Waubojeeg, the chief of the north shore of Lake Huron and both shores of Lake Superior Ojibwes.

Jane's father, John Johnston, was a fur trader who had immigrated to the territory from Belfast, Ireland. Her travels with him to Ireland and England gave her a world perspective unknown to most of her contemporaries. That dual heritage also meant she was fluent in the Ojibwe language, learned the history of the tribe through age-old stories passed down in the oral tradition and grew proficient in native needlework. From her father, young Jane learned to speak, read and write in English. Her reading textbooks were her father's Bible and other tomes in his massive library.

Her native name, Bamewawagezhikaquay, translates to Woman of the Sound that Stars Make Rushing through the Sky. Perhaps it was that lyrical name that inspired her to become the first known native female poet and writer. One also has to wonder if she found it refreshingly liberating to trade that mouthful of a moniker for "Jane."

She began writing in her mid-teens, creating poems and capturing the stories of her people. To further spread the Ojibwe culture, she also translated some of the tribe's songs into English. Literature was something she had in common with her husband, Henry Rowe Schoolcraft, whom

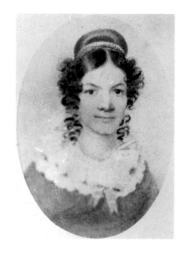

Jane Schoolcraft was the first known Indian woman to become a writer and poet, and her work is still read today. *Library of Congress.*

she married on October 12, 1823, the year after Secretary of War John C. Calhoun appointed him Indian agent of Sault Ste. Marie. He was given the responsibility of studying the Ojibwes and writing about the tribe, which at that time was the most powerful in the Great Lakes region. He had soon become friends with the Johnston family, and though probably immediately smitten with Jane's beauty, he had to have also realized that she would be a major help in his work.

Together the couple published a magazine, *Muzzenyegun* (the Literary Voyager), focusing on the Ojibwe culture. Jane wrote stories for the magazine using the pen names of Leelinau or Rosa. Not surprisingly, she gravitated toward retelling the tales and mythology the tribes handed down through the oral tradition that she had grown up listening to, as the natives had no written language.

Jane's work is believed to have greatly inspired Henry Wadsworth Longfellow's *The Song of Hiawatha*. Historians also believe her husband received credit for a lot of works that Jane actually wrote. One major difference in their literary efforts is that Henry Schoolcraft wrote about the natives to inform the whites, who were his intended audience. Some of Jane's writings, on the other hand, were to help natives, herself included, better understand the changing times of the era. They could also be said to have helped bridge the two worlds in which the author lived.

One of Henry's lighthearted writings was no doubt the result of his great pleasure each time his wife prepared the local favorite, whitefish. He expressed his appreciation in verse:

> *All friends of good living by tureen and dish,*
> *Concur in exalting this prince of a fish;*
> *So fine on a platter, so tempting a fry,*
> *So rich on a gridiron, so sweet in a pie;*
> *That even before it the salmon must fail,*
> *And that mighty boone-boucha, of the land beaver's tail.*

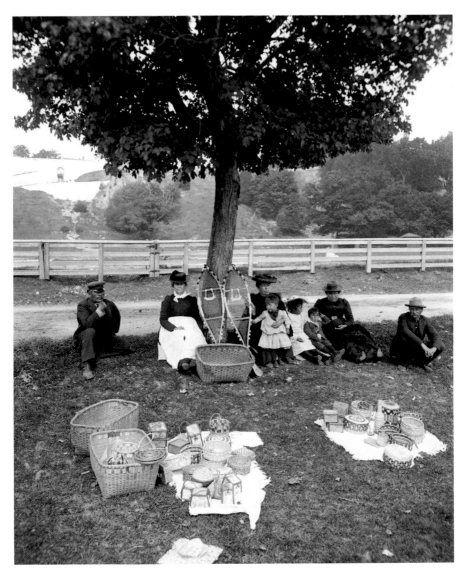

Ojibwe Indians proudly display their handwoven baskets in the 1880s. *Library of Congress.*

In his memoirs, Henry Rowe Schoolcraft tells of taking his beautiful wife to New York, where she was welcomed in high society as Michigan's Pocahontas. Though Jane Schoolcraft was married to a United States citizen, the country did not allow natives to become American citizens until 1924, more than eighty years after her death.

Some historians have said the Schoolcrafts separated after only nine years of marriage due to the stress caused by the death of their son shortly before his third birthday, but this did not happen. They had four children: a son who died in childhood, a stillborn daughter and another son and daughter who survived. Henry was awarded a larger territory, and the family moved to Mackinac Island in 1833 and stayed there until Henry lost his job when the Tyler administration came into power in 1841. Henry and Jane then relocated to New York City, where they were living at the time of Jane's death.

Jane's health had deteriorated, and she died in 1842 while visiting her sister in Canada. She is buried at St. John's Anglican Church in Ancaster, Ontario. That her writings on the native people of Michigan had a lasting impact is proven by the fact that her poetry, essays and translations still appear in literary journals—a well-deserved legacy for a multitalented woman.

Henry Schoolcraft lived another twenty-two years after his wife's death.

ANGELIQUE MOTT

Anyone who has spent time on Isle Royale will agree that it is not a place one would want to spend a winter without adequate provisions. Its remote location in frigid Lake Superior makes it a foolhardy destination for those unschooled in how to survive in extreme weather conditions.

Angelique Mott, a Chippewa, displayed extraordinary courage when her husband, Charlie, a white pioneer, accepted the responsibility of guarding a copper mine claim for the summer of 1845. Lured by the promise of thirty dollars a month, they traveled to the island's isolated southwestern tip. They had been hired by Cyrus Mendenhall, who assured them he would not only bring them everything they would need but also that he would come for them and take them back home in three months. She thought it was too much of a risk, but they had been promised ninety dollars. Money was tight, and that was too much for Charlie to walk away from. Against her better judgment, Angelique agreed to go. She had to admit that the money would come in handy over the next winter when no work could be found.

The supplies Cyrus Mendenhall promised never came, and neither did the boat that would take them home to the Michigan mainland. All they had was some flour, spoiled butter and a small quantity of beans. It wasn't too

bad in the beginning, as they were able to fish and the forests still had berries to pick. For the first weeks, they caught fish and foraged berries. Then a brutal storm blew their boat away. By then, winter was getting closer every day, and all they could find to eat was roots, bark and a few bitter-tasting berries. Reality set in: the boat wasn't coming. They had nothing to eat. They would die on Isle Royale. The worst thing about that was that it would be a slow, miserable death by starvation.

Just when Angelique must have thought it couldn't get any worse, it did. Charlie went mad. He started waving a sharp knife in her face and promised to save them. It would be easy, he said. All he had to do was go out and find a sheep to kill. Angelique was never one to kid herself. She was her husband's sheep, and she knew it. All she could do was stay awake until his madness ran its course. Eventually it did, and she took the weapon away from him. He died a week or two later. She no longer had to worry about ending up on his dinner plate, but she was now alone in literally freezing cold weather with hardly anything to eat.

But that wasn't her only problem. What does one do with a dead body when the ground is frozen solid? She needed to stay as warm as she could, but her cabin fire would decompose Charlie. She finally decided the only thing to do was to build a Chippewa-style lodge that she could live in until spring. It wasn't easy, as she was not only weak from hunger but also had hurt her shoulder nursing Charlie as he lay dying.

Some Chippewas would have been frightened of the Northern Lights and seen them as the Bad Spirit, but she had been raised in a mission and embraced the Christian faith. What Mott called "the biggest trouble" was overcoming the temptation to make soup of Charlie. She said she prayed daily for the strength to resist what she knew was wrong.

By then, she figured the best thing she could do was die too, but no one ever called Angelique Mott a quitter. Drawing on strength she didn't know she had, she pulled herself together and soldiered on. Weeks passed. Then one morning, a miracle. She first thought she was hallucinating, but no, there they were: rabbit tracks in the snow outside her lodge. Using her own hair, she crafted a snare and caught the rabbit.

In March, the melting snow uncovered a canoe that had washed ashore. Soon she could fish. Mott's confidence grew each day. One bright May morning, she was frying up a hearty breakfast of mullet when gunshots rang out on the lake. At last, someone was coming! Among the visiting party that rowed ashore was Cyrus Mendenhall, the man who had abandoned them those long months ago. Mott took them to the cabin where her husband's

body still lay. Mendenhall appeared grief-stricken and insisted he had sent the boat with provisions and didn't know it never arrived. Another man took her aside and said it was a lie. The winter she spent alone on Isle Royale Angelique Mott was only seventeen years old.

Mott survived overwhelming odds and lived in the Upper Peninsula for another thirty years, first in Marquette and then settled permanently in Sault Ste. Marie. That's where she bet a Frenchman that she could carry a barrel of pork to the top of a hill and back. Thinking it was a sure thing, he argued that she couldn't. After winning the bet, she asked him if he wanted her to tote it up the hill again—this time with him in it!

The Upper Peninsula was not for sissies, and its women proved more than able to hold their own. Isle Royale is today a national park, and the area where Angelique spent the winter of 1845–46 probably looks much as it did then. The National Park Service Isle Royale Headquarters are located on what is called Mott Island. Across from the structure, a stretch of the coastline is named Starvation Point as a permanent memorial to the strength and courage of the young woman who endured the unendurable.

Of course, people in the UP are different. Yoopers, they call themselves. Those living in the Mitten are trolls, as they live under the Mighty Mac Bridge. Yoopers identify more with Wisconsin and even Minnesota than their fellow Michiganders. Looking at a map makes that easier to understand. From the UP's westernmost point, Duluth, Minnesota, is but 100 miles away, while Detroit is not only a whopping 605 miles distant but is also in a different time zone. Many support the Green Bay Packers rather than root, root, rooting for the Lions; of course, that may be because it's more satisfying to line up with a winner.

Paradise, Michigan, is in the UP, but Hell is in the Mitten. One might expect Hell to have an abundance of wild women. Actually, not so many. The town got its unholy name when the first settlers couldn't agree on what to name their new home. One resident grew tired of the constant bickering. "Name it Hell for all I care," he said. They did.

Paradise, found on Lake Superior's wind-battered southern shore, not only freezes over first, but a woman would have had to be a bit wild to have settled there. Most soon mastered the required skills and could not only bring home the (delete bacon and insert venison, duck or the occasional roast of moose) but were also able to shoot, butcher, clean and cook said entrée. They could also catch the whitefish and smoke it to perfection. Slapping a new coat of whitewash on the outhouse counted as a home

improvement project. A popular song in the 1950s told us that Davy Crockett "kilt him a bear when he was only three." Had Crockett lived in the UP instead of Tennessee, it might well have been his mother who taught him how.

Each winter, Caroline Masters of Munising had to mush a dog team to high school and back, so she decided to put that time to good use by working a trap line and every day checked her traps for the mink, marten, beaver or fox she might have snared. Like most UP women, Masters was up for whatever challenge arose.

Some of their menfolk had been drawn by copper and iron mining, while others worked as lumberjacks. All these jobs came with extreme danger. Those with roots in places like Norway, Finland or Sweden saw the bitter cold winters as little more than an inconvenience. Winters are brutally long, and in summer, aggressive mosquitoes can make residents look forward to frigid January. But as Yoopers say, "If it wasn't for the snow and the skeeters we'd just be another Saugatuck." Maybe, but it's unlikely anyone ever accused Saugatuck in southwest Michigan of being balmy for more than a few days per summer.

Settling new land is difficult at best, life threatening at worst. These hardy pioneer women worked as hard as their husbands and needed skills far above the job description of the usual housewife. They lived lives of deprivation that required enormous amounts of courage coupled with ingenuity simply to survive. The Finns call it *sisu* and consider it a trait of their nationality. It translates to courage and strength.

Chapter 2
IT'S ALL IN A DAY'S WORK

Women who seek to be equal with men lack ambition.
—Timothy Leary

In 1914, the federal government issued a report showing the top four occupations for American women were servant, teacher, stenographer and nurse, in that order. More than a few broke out of the mold and took their places in occupations dominated by men. They shattered glass ceilings long before anyone had heard the term.

Teaching was a highly regarded profession and one of few open to women, though why a woman would have chosen it is a bit of a mystery. Conditions were appalling in the earliest days. One young teacher referred in letters home to "the miseries of school teaching."

"'Tis a dread," she wrote of her job that would begin the following day. She received a $2-a-week salary and had to board at a student's house, moving frequently from one Macomb County farmhouse to another. By the end of the Civil War, a teacher near Detroit, in Smithville, earned a whopping $47.50 for three months' work. She also boarded with parents of students, and for that $47.50, she had to herd eighty-nine kids of all ages in her one-room schoolhouse. Most women taught only a few years before marrying, as committing matrimony resulted in automatic dismissal.

Mary White, Grand Haven's first teacher, found it a bit easier when she came in 1835 at the invitation of her sister and brother-in-law, Reverend William and Amanda White Ferry. The Ferrys were founders of the

Left: Female stenographic employees are shown in the windows of the J. Simon Company in 1865. *Library of Congress.*

Right: Mary White came to Grand Haven to teach her sister's children and then went on to a successful teaching career as the city developed. *Loutit District Library.*

settlement and needed someone to teach their own children and then others as the area grew. Their first choice was Amanda's sister Mary, then teaching at a private school in Massachusetts. Lured by the excitement of a pioneer post on Lake Michigan, White packed her bag and headed west. She held her first classes in the Ferry home, but by 1850, the flourishing township had built a new school.

ANNE DEVRIES BRINKS

Anne DeVries grew up on a farm in the tightknit Dutch community of McBain during a time when most women expected to be homemakers. Anne thought she could do more and set her sights on becoming a teacher. That all changed when her mother died during childbirth. Her older brother was

serving in World War II, and her older sister, Wilhelmina "Willie," married when her fiancé Bert returned from his military service, making Anne the oldest of the seven siblings still at home. Without hesitation, she dropped out of school at fifteen and took over the monumental task of caring for a large family, the youngest of whom was a baby.

Though college was no longer an option, Brinks hid any disappointment she might have felt and gave her all to the task at hand. "Her all" included making dresses for her sisters. Betty Groen, now living in Thousand Oaks, California, remembers her yellow eighth grade graduation dress—yellow chiffon festooned with yellow ribbons. Anne made her sister Jessie's wedding dress, a dress that Betty later wore for her own wedding. Marge Koetje of Zeeland remembers dresses and also the treats Anne provided during long summer days spent working in the fields. At break time, Anne would appear bearing dessert pancakes still warm from the oven, buttered and then rolled and coated with powdered sugar.

For many, that would have been the end of the story. Not Anne. After six years, the next sister in line took over the responsibility of house management. That left Anne free to complete her high school diploma, which she did in only one year and then enrolled in Calvin College, where she earned an undergraduate degree followed by two master's degrees.

Devout in her Dutch Calvinist faith, Anne DeVries was finally ready to teach—but not just anywhere. Any of the Christian schools flourishing in Michigan would have been lucky to have her, but once again, she thought she could do more. "I never believed being a single woman could stop me from serving God," she explained.

She found her true calling teaching in one of her church's missions in Zuni, New Mexico, where she was loved by her Native American students and their parents. It's safe to say that she inspired youngsters throughout her career, but she also had a strong influence at home. Betty remembers telling a classmate, "I'm

After retiring from her career of teaching in a New Mexico Zuni mission, Anne DeVries Brinks married her brother-in-law and lifelong friend, Bert. *Author's collection.*

going to go to college like my sister Anne." She did and also taught Native American children in the Southwest.

Following retirement, Anne took on a new role in life. Her sister Willie had died five years earlier. It was time for Anne to have the marriage she had postponed in pursuit of her education and career. She married her lifelong friend and widowed brother-in-law, Bert Brinks, in 1992. The bride's brother, Reverend Jay DeVries, officiated, and the couple enjoyed nineteen years together before Anne succumbed to pulmonary fibrosis in 2011.

Another early occupation was farming, though conventional wisdom held that the man farmed while his wife's job description included everything else. "Everything else" was a broad term that included cleaning, washing, ironing, cooking and raising the children, at the very least. Washing initially meant beating the clothes on rocks in the nearest stream. Eventually, the technology of the day streamlined the process to using a washboard and large tub of water that first had to be boiled for the job. After the woman hung the last garment to dry, often in the house due to inclement weather, she used the wash water to scrub stoops and floors.

Other chores included churning butter, sewing the family's clothing, keeping a kitchen garden and putting up food for the coming winter. Even so, these women often managed to eke out enough spare time to pitch in with farm chores. No doubt it was farm women who inspired the saying "man works from sun to sun, but woman's work is never done." Farming didn't always mean sitting high on a tractor or other farm machine. The lady pictured on the following page had to work hard to steer the horse-pulled plow in a manner that would allow the seeds she sowed to grow in straight rows spaced far enough apart for weeding and harvesting.

It's no surprise that some of these women worked themselves into early graves. Others died in childbirth. In this instance, the bereaved husband often took a second wife and fathered more children. Additional hands were always needed on the farm, and far too many children succumbed to diseases that have since been eradicated.

A few women actually farmed. Often it was because they were farmers' widows. That was the case with Elizabeth Joyce, who married H.D. James in Herkimer, New York, in 1858. The young couple came to Michigan and eventually bought farmland in Kalamazoo County in the area near Charleston Township. The family prospered and had every reason to expect happily-ever-after bliss. Then tragedy struck in 1887. H.D. was working his fields when his team ran away, causing fatal injuries. After H.D.'s death,

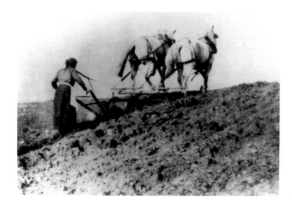

It could be said that today's farmers have it easy compared to the woman shown here. *Heritage Hall, Calvin College.*

Elizabeth took over the farm and quickly learned to manage every detail. This tireless farmer also took care of her house with no domestic help, and though she caught a break in winter when she only had to take care of her livestock, her summers had to have been backbreaking. Her only hired help was a man she relied on year-round and a few part-time farmworkers during the busy growing seasons.

MARY ANNE MAYO

Mary Anne Mayo didn't single-handedly manage a farm as Elizabeth James had, but she did turn farming into her life's work. Her greatest contributions came in the form of tireless Grange work. She believed whole-heartedly in education, and her own schooling had consisted of, first, a New England private school where her two aunts taught, followed by Battle Creek High School. Her natural love of learning led her to home study via the Chautauqua Reading Circles, which she continued even after her marriage.

The famed Chautauqua Institution was founded in Chautauqua, New York, in 1874 by Bishop John Heyl Vincent and Lewis Miller to foster a lifelong quest for knowledge in its followers by making higher education available to those unable to attend traditional colleges. Four years later, they introduced home study programs for those geographically too far removed from New York.

In April 1865, Mary Anne married Perry Mayo, who had just returned home from Civil War service in the Union army. They had two children. The couple bought a farm complete with log cabin in Marshall Township. Perry, too, continued his education with home study. Farming led them to

join the Grange. The organization's full name was National Grange of the Order of Patrons of Husbandry, and it was founded in 1867 for the purpose of encouraging farm families to band together to promote the economic and political well-being of the country's post–Civil War agricultural communities. It was nonpartisan, and at least two presidents were members: Franklin Delano Roosevelt and Harry S. Truman.

Mary Anne became increasingly involved and, with Perry, served as a delegate to statewide events. She enjoyed lecturing on the Grange circuit. Her previous exposure to social and study clubs led her to believe that the Grange could serve the same purpose of educating women, particularly in dealing with the often overwhelming demands of farm life. She also sensed that in belonging to an organization of others facing the same challenges, they would feel less isolated and more empowered. "Empowered" was probably not the word she would have used, as the words "women" and "empowerment" were still regarded as mutually exclusive and seldom used in the same sentence.

Mary Anne Mayo was an early pioneer in introducing many of the organization's programs focusing on women. One way she accomplished this was starting and chairing a women's work committee. She also started the Fresh Air program, which enabled underprivileged city kids, mothers with young children and working women to spend idyllic summer weeks enjoying country life in the farm homes of Grange members.

Had she been asked, Mayo probably would have been most proud that her years of exhaustive works toward the betterment of farm life led to a new women's department at the Michigan State Agricultural College. The college, now Michigan State University, named its new women's dormitory the Mary Mayo Hall, an honor she richly deserved. So beloved was Mayo that one woman called her the patron saint of farm women. Her dedication to the Grange lasted her entire adult life. She served the organization as a chaplain for twelve years and still held that position at the time of her death in 1903.

Who would have suspected that some early would-be nurses had the audacity to believe they could better serve the ill by becoming doctors themselves? Those trailblazers bucked the system and went on to earn medical degrees instead of nursing certificates.

Michigan's early female doctors include Frances Rutherford, who was the first woman to practice medicine in Grand Rapids when she was appointed city physician in 1870. Rutherford was one of the first three women allowed

to join the Michigan State Medical Society. Joining forces with Dr. Frances Hillyer, she opened the state's second school of nursing, this one at the Grand Rapids Union Benevolent Association Hospital. Hastings physician Delight Wolfe opened her practice in 1878. Despite the possibilities the name "Dr. Delight" might have suggested, she was a general practitioner.

Emma Greene never earned a medical degree but assisted her husband, Dr. Charles Greene, in his medical practice in Macomb and St. Clair Counties in the late 1800s. No one could call her squeamish, as she spent her days helping Charles stitch wounds, treat diseases and scrub his often bloody office. His patients called her "Mrs. Doctor," and she later told a reporter that while Charles was in medical school, it was not uncommon for the couple to sleep with a skeleton stashed under their bed. She mixed up batches of cough medicine and performed whatever tasks Charles required of her but drew the line at pulling teeth. Greene grew used to having her plans cancelled when the duties of a country doctor called. She even took it in stride when she occasionally had to turn her house into a makeshift hospital when the nearest one was too far away for the patient to travel or bad weather made travel impossible.

Along with the few doctors and many nurses, midwifery was another healthcare field and was dominated by women. These women delivered babies way back when babies were born at home, often without the presence of a doctor. The midwives usually worked with pioneers of their own ethnicity, thus giving comfort to young mothers who might not yet be fluent in English.

PEARL KENDRICK AND GRACE ELDERING

Grand Rapids lays claim to two highly motivated women who worked incessantly toward vastly improving the health of children. Children not just in Michigan, but everywhere, could thank two Grand Rapids medical researchers for not falling victim to diseases that too often proved fatal. It would be impossible to put a number on the lives saved by Drs. Pearl Kendrick and Grace Eldering, but it would be in the millions. And still counting.

The two first met in 1932. Dr. Kendrick, then chief of Michigan's medical laboratories in Grand Rapids, welcomed the newest employee, Dr. Eldering. Their backgrounds were quite different, but they followed similar paths toward finding their life's work. Kendrick, born in 1890, was the daughter of

a Methodist minister, and the family had moved frequently as he answered calls to scattered congregations. She tried teaching but realized what she really wanted was a scientific career. Following her heart, she earned a zoology degree from Syracuse University. Then she went back to teaching. Initially, teaching was a good fit. As Eldering would later say about her colleague, "She wanted everyone around her to know all there was to know about a subject, so that they too, could share her wonder and excitement."

Then came World War I, and as in both world wars, women stepped up and took on civilian jobs formerly held by men. Probably no one did this more eagerly than Pearl Kendrick. Once exposed to the emerging fields of bacteriology and microbiology, she was hooked. At age twenty-seven, she studied parasites at Columbia University. Her fate was sealed. After passing a rigorous civil service exam, she went to work at the state laboratory in Auburn, New York. Her first assignment forever changed the course of her life. Kendrick was asked to lead a research group seeking a diphtheria vaccine.

A Michigan scientist lured her away to a new position in Lansing and, in 1926, transferred her to Grand Rapids, where she would be the associate director of all state laboratories. One of her responsibilities made her available 24/7 to respond to emergencies. Often those emergencies were diphtheria cases, where a correct diagnosis early on could mean the difference between life and death. Other duties performed by Kendrick and her staff were doing diagnostic tuberculosis tests in twenty-eight Michigan counties and the city of Grand Rapids and making sure milk and water supplies in western Michigan remained free of contamination. During all this, she found time to continue her studies in the fields of pathology, microbiology and immunology.

Grace Eldering described her friend and medical partner as an optimist: "Optimism spread around her, as contagious as measles or the common cold."

Eldering was born in 1900 to immigrant parents. Her mother came from Scotland, her father from the Netherlands. Like Kendrick, she first worked as a teacher. She, too, wanted more and gravitated toward science. She taught until she had saved enough money to attend the University of Montana, where she earned a degree in microbiology. She chose medical research because she couldn't afford to go to medical school and become a physician.

Eldering also worked first in Lansing before being assigned to Grand Rapids. She eventually earned a doctorate in bacteriology. It should come as

no surprise that these two women with so much in common would develop a friendship that spanned fifty years.

They decided to research a vaccine for whooping cough, also called pertussis, as both had the disease in childhood. It would be a major undertaking, as they and their staff of six still had to carry out their other assigned responsibilities. After hours, they collected specimens from children afflicted with the disease, often by the light of candles or kerosene lamps in poor households lacking electricity. Kendrick and Eldering injected themselves with the vaccine to be sure it was safe. These indomitable women not only did medical research but also had to raise some of the funds to conduct it.

Despite those formidable challenges, they succeeded. Up until 1940, when the State of Michigan began producing and distributing the vaccine, whooping cough caused more than six thousand deaths each year, and children under the age of five were hit the hardest.

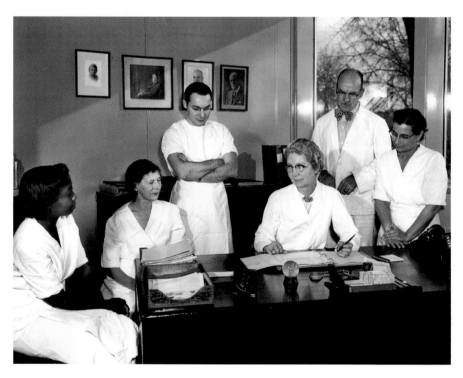

Grace Eldering (*fourth from left*), who, with Pearl Kendrick, is credited with creating the diphtheria vaccine, followed by the DPT vaccine. Other team members included Loney Clinton Gordon, shown at far left. *Grand Rapids Public Library.*

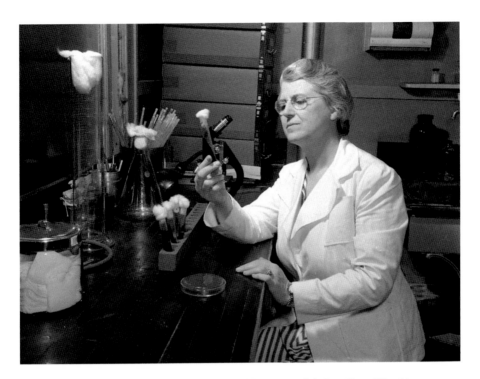

Pearl Kendrick, whose vaccines saved countless lives, at work in her Grand Rapids laboratory. *Grand Rapids Public Library.*

Finally, the vaccine was ready to test in a control group: 4,000 children were selected, and half were inoculated. Four years later, nearly 350 unvaccinated children had come down with the disease. Only 52 children who had received it had contracted pertussis, and the good news was that they suffered mild cases. The vaccine was a success! When further testing confirmed its safety, the Michigan Department of Health started manufacturing the vaccine. With typical grace, Kendrick and Eldering refused to grant permission for the vaccine to carry their names, saying that so many people were involved in the project that it would be unfair for the two of them to take all the glory.

Even then, they refused to rest on their laurels with what most would have correctly considered a major accomplishment. Instead, they continued their research until they were able to combine the original vaccine with diphtheria and tetanus vaccines, creating today's three-in-one lifesaver, the DPT (diphtheria, pertussis and tetanus) vaccine. That shot is still in use and has all but eradicated those once dreaded childhood killers—not just in Michigan, not just in the United States, but around the world.

Pearl Kendrick succumbed to bone cancer in 1980 at age ninety. Grace Eldering died in 1988; she was eighty-eight. A *Detroit Free Press* reporter writing about these remarkable women said it best: "If Grace had never met Pearl, you might not be alive today."

As they themselves generously pointed out, others were involved in the momentous work of bringing the vaccines to fruition. One of those team members was Loney Clinton Gordon, a lab technician originally from Arkansas who moved to Michigan with her family during her early childhood. She earned a degree in home economics and chemistry, but her dream of becoming a dietician was derailed when she realized white male chefs would balk at taking orders from a black female dietician.

Gordon learned Kendrick and Eldering were looking for a laboratory technician and applied for the position. She soon became an enthusiastic and committed member of the team. One of her responsibilities was testing literally thousands of plates searching for the culture that would work. Eventually, she discovered sheep's blood was the agent that would incubate the culture in the petri dish. Loney Clinton Gordon died in 1999 at age eighty-four.

ELIZABETH EAGLESFIELD

The practice of law and employment in the field of law enforcement were both thought to be way too messy for the so-called weaker sex, as they were considered creatures to be shielded from life's seamier side. As always, there were exceptions. In 1878, when Elizabeth Eaglesfield hung out her shingle reading "Attorney at Law," she secured her place in local history as Grand Rapids' first practicing female attorney.

Actually, Eaglesfield had already made history three years earlier at the age of twenty-two when she became the first woman admitted to the Indiana state bar. That had been a nearly impossible feat because Indiana's state constitution plainly stated that only voters could be admitted to the bar, and women were still years away from winning the right to vote. But she never defined "impossible" literally. To her, the word never meant she couldn't do something, only that doing it might take a little longer.

She attended the University of Michigan, first earning a degree in literature and then following that with one in jurisprudence. Unlike most early female attorneys, Eaglesfield refused to limit her practice to the office

and argued cases in court whenever a client had enough faith in her abilities to trust her to do so. According to the Michigan Women's Hall of Fame, there was little she didn't do: "Records illustrate the attempts of this atypical woman attorney to cobble together a living as a guardian for minor children, a representative for widows in property disputes, and representing herself in real estate trades."

Eaglesfield wasn't satisfied with simply becoming the city's first female attorney. Like Anna Bissell and other women of her time, she didn't think a demanding career exempted her from the responsibility of civic involvement. One might think that with all those balls in the air, she would be incapable of juggling one more. Not Eaglesfield. She regularly participated in various women's organizations that existed for the betterment of the community.

Then adventure called, and Eaglesfield answered. She so loved spending time on Lake Michigan that she went on to become a licensed Great Lakes boat captain. Eaglesfield soon owned a fleet of five steamships, including the *Golden Girl*, that could carry up to ten thousand cases of fruit from Benton Harbor to various Great Lakes ports. Though female steamship captains on the Great Lakes were far from the norm, she was not the first. That distinction belongs to Alice Chaney of Detroit.

Elizabeth Eaglesfield's vast legal experience enabled her to succeed at the next stage of her amazing life. She limited her legal work to issues concerning her beloved lakes. Then she added one more ball to her juggling act by becoming a major player in the Benton Harbor real estate world. When she retired in the 1930s, her enduring legacy to women was one of facing challenges head on and never accepting the status quo. She died in 1940 at age eighty-seven.

CORNELIA KENNEDY

Cornelia Kennedy's illustrious career in law came nearly a century after the groundbreaking work of Elizabeth Eaglesfield. Appointed to the Michigan federal bench by President Richard Nixon in 1970, her work earned her the designation "First Lady of the Michigan Judiciary." Long before leaving her mark on the Michigan court, the Detroit native had earned the respect of all who came to know her.

It's no surprise that Kennedy gravitated toward a law career, as her father was a prominent Detroit trial lawyer. Her mother was a law student at the

time of her death when Kennedy was only nine years old. Both parents expected their three daughters to nourish big dreams and to let nothing stand in the way of making them happen. Her first legal job was working in her father's law firm, where she proved herself a top-notch lawyer and a whole lot more than the boss's daughter.

Eighteen years later, in 1966, the successful attorney ran for and was elected a Wayne County Circuit Court judge. She would remain on one bench or another for forty-six years.

Kennedy always made it a point to encourage other women, but not in an abrasive manner. She never waved a sign or burned a bra but simply passed on her own philosophy: "Do a little more and do it better than a man." Oh yes, that and similar sentiments became feminist mantras, followed by the line, "Fortunately, that's not too difficult." That was said as a joke, because no matter how deep their feminism ran, most would readily admit that some of their favorite people were, in fact, men. They may have seen men as adversaries in the workplace, but most welcomed them in their personal lives. Even Gloria Steinem of "A woman needs a man like a fish needs a bicycle" fame eventually married. Perhaps the real message behind those sweeping sentiments is that a man and woman should come together out of mutual affection and respect, not unvarnished need.

"If someone tells me I can't do something, my reaction is, if I feel I can, I WILL do it." It didn't take long for people to stop telling Cornelia Kennedy what she couldn't do. Even though the time was right for women to make unprecedented advances, making it easier for Cornelia than the women who came before her, it was still an uphill struggle. And that struggle probably made her even more motivated. She loved taking on new challenges and would have been bored by an easy climb up the judicial ladder.

When President Ronald Reagan made history by deciding to appoint a woman to the Supreme Court, Cornelia Kennedy was on his short list of two nominees. The other female contender was Sandra Day O'Connor. Senator Orrin Hatch summed up Kennedy's ability to serve on the highest court in the nation when he studied her résumé and said, "By damn, you have a lot of qualifications."

Sandra Day O'Connor had a lot of qualifications as well, and she, not Kennedy, became the first woman appointed a Supreme Court judge. Gracious as always, Cornelia Kennedy wrote to a colleague, "I am, of course, disappointed but not dispirited."

Her judicial career spanned forty-six years, and this tireless woman didn't retire until age eighty-eight, two years before her death on May 12, 2014.

IDA LIPPMAN

Another notable exception in the field of law and law enforcement was Ida Lippman, a Massachusetts native who lived in New York before making Detroit her home. It was in New York that her attention was drawn to the plight of incarcerated women, especially the younger ones. She believed in second chances, and it troubled her that one early mistake could forever keep these inmates from achieving their untapped potential. Ida took a job at the New York State Reformatory for Women in Bedford Hills during the years preceding World War I. Part of her responsibilities put her in direct contact with female inmates, thus giving her firsthand knowledge of the uphill struggle these women faced. She later became a parole officer, helping young girls in the corrections system find their way back into society.

That work was interrupted by a stint in France during World War I with the Quartermaster Corps. After completing her service, the Detroit Police Department brought her to Michigan to organize a women's division. During her time on that job, Lippman, who would today be called an overachiever, earned a law degree at the University of Detroit.

After completing her studies, Lippman left the police department with the rank of sergeant and worked briefly in the Wayne County Prosecuting Attorney's Office. She had gone full circle and was once again doing what she loved most: helping women and teenage girls. But fulfilling though the work was, she was not a woman who could be content working for someone else, so she went into private practice and concentrated on the civil and legal rights of women.

Wars have a way of disrupting the best-laid plans, and World War II brought Ida Lippman new challenges. She was one of seven, and the only woman, recruited to travel to Seoul, Korea, to assist the local law enforcement professionals. Ida's task was organizing a division of Korean policewomen. Her work earned the respect of General Douglas McArthur, who said, "Her initiative, tact, professional ability and untiring efforts to solve the complex problems involved in the creation and operation of a Women's Bureau of the National Police, have been an inspiration to all personnel associated with her."

She later became president of the Women's Overseas Service League and worked with a number of Detroit-area professional women's organizations until her death in 1980.

Also involved with improving the lives of incarcerated women was Detroit activist Katherine Hill Campbell. She was particularly concerned with the

way young girls convicted of minor offenses like shoplifting were put in cell blocks with murderers and prostitutes. At the time, overcrowded facilities left officials with no choice. Hill was convinced that instead of allowing the offenders to pay their debt to society so they could move forward and live productive lives, they would more likely be schooled in more serious crimes.

She thought female prisoners would fare better if housed in cottages with no more than thirty inmates. By 1929, some of her ideas had been put into practice, and Campbell was named the first superintendent of the new Detroit House of Corrections, a post she held for ten years.

Clarissa Young became one of the first female Lansing police officers soon after World War II. She is remembered for thinking outside the clichéd box and found ways for the police, social agencies and schools to work together to creatively solve community problems and reduce violent crimes. Young worked her way up through the police hierarchy and had reached the rank of captain at the time of her retirement.

ANNA SUTHERLAND BISSELL

Originally from Canada, Anna Sutherland was born in St. John, Nova Scotia, in 1846. In her early childhood, the family moved to DePere, Wisconsin. There she met and married Melville R. Bissell. Three years later, the young couple moved permanently to Grand Rapids.

She lived an enviable life as a respected pillar of local society and wife of the founder of the Grand Rapids–based Bissell carpet sweeper company. Actually, Melville's first foray into business was as proprietor of a crockery shop. Carpet sweepers were the direct result of Anna's struggle to keep the shop floors clean. Melville suffered allergy attacks whenever he unpacked new cases of dishes. Dust generated by the packing material necessary to protect the dishes was to blame, and Anna, though she tried, was unable to keep ahead of the problem. The war escalated. The dust was winning.

It was probably a combination of loving a challenge and "happy wife, happy life" that led Melville to put together a rotating brush that swept the dust into an attached container for easy disposal. The gadget proved far superior to brooms, as they usually redistributed almost as much dust as they cleared away. In 1876, he patented his invention and began manufacturing it. The Bissell carpet sweeper became an instant success

and was soon internationally known. Housewives and maids alike spoke of "bisselling" the floors. Even Queen Victoria was said to insist her floors be regularly "bisselled."

Melville and Anna Bissell were a team. When he traveled to sell the product to retailers, she not only accompanied him but also made sales calls of her own. Back when downtown areas had multiple department stores, Melville worked one side of the street and Anna the other, thus enabling them to visit twice as many prospects on any given day. One of her early successes occurred when Philadelphia's Wanamaker's bought her sample and ordered a dozen more. Neither could have guessed how valuable Anna's experience would become.

In 1889, just thirteen years after launching the company, Melville died of pneumonia, leaving Anna with four children to raise and a company to run. She knew the business, having been actively involved since day one, and never saw selling it as an option. Instead, she rolled up her sleeves, went to work and became a captain of industry, serving as president for twenty years and as board chairman for another sixteen.

Five years after Anna Bissell took the reins, fire destroyed the Bissell manufacturing facility. Once again, Bissell rose to the challenge. In the days when few women even had bank accounts, she met with bankers and secured loans to rebuild. Then she hired contractors and oversaw the construction. She ran the business with great success for another twenty-five years.

It might be assumed that the male workforce would balk at working for a woman, especially at that particular time, when Grand Rapids reigned as Furniture City and jobs were plentiful. That assumption proved false, as Bissell held progressive ideas about how a company should treat its employees. Workers might have resisted female bosses in general, but no one could possibly object to working for this particular woman. She paid competitive wages, and under her leadership, Bissell became what is believed to be the country's first corporation to offer retirement plans and other employee benefits. A wild idea indeed, but she believed it was one whose time had come.

The company flourished, but Bissell did more than run the largest corporation of its kind in the world. She felt that with privilege came a responsibility to serve the community. She also cited a selfish reason for her involvement, saying she coped with her own grief by helping those who were even more unhappy. One way she did so was by founding Bissell House, a facility providing job training and a social outlet for immigrant women, along with recreation and support for underprivileged children.

Right: Anna Bissell was thrust into the role of managing a large manufacturing company when her husband died, leaving her to run the family business. *Bissell Home Care Company.*

Below: Cathy Bissell with a few of her handsome friends. *Bissell Home Care Company.*

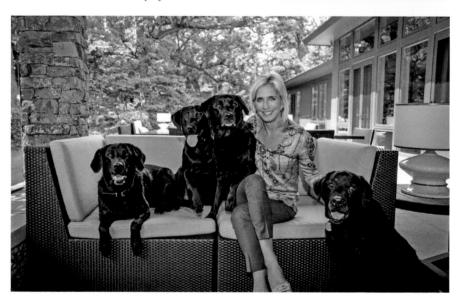

Bissell is especially remembered for her tireless work on behalf of children. The Blodgett Home for Children was dear to her heart, and she took great pleasure in helping place infants in homes where they would be cherished. Before abortion became legal, there were a lot more infants available for adoption, and adoptive parents had specific requirements regarding their new family member. Bissell later recalled with amusement the couple who requested a two-month-old with a keen intellect. She must have wondered how exactly one could accurately measure the IQ of an infant. Other couples

seeking to adopt could be described as a bit more shallow. Appearance was what mattered most to them, and they placed "orders" for girls with blond hair, blue eyes and dimples.

The company, today called Bissell Home Care, is still family owned and a leader in its field. Carrying on the tradition is Mark Bissell, current CEO and great-grandson of Anna and Melville. When he spoke in 2016 at the unveiling of Anna Bissell's statue outside DeVos Place in downtown Grand Rapids, he described Anna as a tough lady with a big heart. The seven-foot bronze statue was carved by Ann Hirsch and demonstrates Bissell's rise to corporate power. Its base is at a slight angle so that Anna appears to be facing the challenge and moving toward her new role as a business heavyweight.

Cathy Bissell, wife of Mark and director of corporate affairs, can be seen advertising the Bissell line in television ads. Those ads tie her to what she loves doing most: advocating for animals. Cathy drew on a lifelong love of pets when, in 2011, she founded the Bissell Pet Foundation to assist animal welfare organizations around the country. The foundation vastly extends the Bissell reach and promotes adoption, microchipping, spaying/neutering and foster care. Bissell Home Care was involved in the cause even before the foundation. One way was through an annual fundraiser since 2005, the Blocktail Party, billed as the Best Doggone Party in Town.

Unlike Anna Bissell, Dorothy Scott Gerber didn't run a family corporation. She was, however, the one who inspired its present form. Gerber was the wife of Dan Gerber, who ran the family business, the Fremont Canning Company. This Fremont mother reasoned that a much-needed product should be added to the existing line: strained baby food. In 1928, after samples were enthusiastically received, Dorothy Gerber herself embarked on a cross-country promotional tour. She then launched a syndicated newspaper column, "Bringing up Baby: Hints by Mrs. Dan Gerber, Mother of Five." Today, the company markets only baby products and has a new name: the Gerber Products Company.

Ella Eaton Kellogg

Ella Eaton was born in Alfred Center, New York, in 1853. She graduated from Alfred University in 1872 with the equivalent of today's bachelor of arts degree in classic studies. At nineteen, she was the youngest person, male

or female, to graduate from the school. It was while visiting a relative in Battle Creek that she met the man who would change her life. An outbreak of typhoid fever crippled the city, and young Ella stayed on to help nurse the stricken. That brought her to the attention of the prominent Battle Creek physician Dr. John Harvey Kellogg, who was the proprietor of the famed Battle Creek Sanitarium.

The San, as it was called, treated its patients holistically, relying on a vegetarian diet, exercise, enemas and the teachings of the Seventh-Day Adventist Church. Dr. Kellogg and his brother Will Keith worked together and were soon known for the invention of corn flakes, which were actually a happy accident. Someone forgot to remove a tray of a corn mixture from the oven. When it was discovered, a new breakfast food was born. Soon the San was treating the likes of Henry Ford, Thomas Edison, Sarah Bernhardt, William Henry Taft and Lowell Thomas, to name but a few of the notables who found peace and healing in the natural treatments.

Dr. Kellogg invited Ella Eaton to become a charter member of his School of Hygiene. That greatly appealed to her, and over time, she developed what she called the new field of dietetics—food selection and preparation based on science. The two married on February 27, 1879, and worked together until her death in 1920 at age sixty-seven.

Kellogg worked like a demon and gained national recognition as a dietician, writer and children's advocate. For more than forty years, she served as an editor and major contributor to *Good Health*, a periodical published by Dr. Kellogg. That was a small part of the responsibilities she took on. One of the initial problems with health food was that it didn't taste very good. To remedy that, she took over the kitchen, where, through trial and error, she began turning out dishes with both visual and taste appeal. It wasn't long before her repertoire contained enough recipes to provide menus for three meals a day for both the staff and the patients.

Her expertise in domestic arts soon expanded to include methodology in child raising. Ella Kellogg again felt a duty to share her discoveries. She made major contributions to home economics by founding the School for Home Economics (which later became part of Battle Creek College) and a cooking school held at the sanitarium. In 1888, she and Dr. Kellogg began a School of Domestic Economy. Out of that came the book for which she is best known, *Science in the Kitchen.* John Kellogg's publishing company, Health Publishing, released the book, and it had a lengthy subtitle or explanation, which read "A Scientific Treatise on Food Substances and

Their Dietetic Properties, Together with a Practical Explanation of the Principle of Healthful Cookery and a Large Number of Palatable and Healthful Recipes." There, in an oversized nutshell, is the philosophy by which Kellogg ran her kitchen.

The famed Battle Creek Sanitarium, where Ella Eaton Kellogg devised menus and provided education throughout her adult life. *Author's collection.*

She was just as dedicated to her work with children. The couple was unable to have biological children, but the Kelloggs didn't let that stop them from raising more than 40, including 8 they adopted. All were taken from the Haskell Orphanage they founded. At any given time, there were an average of 150 residents. For more than twenty-five years, she was the home's CEO. Once again, she shared the expertise she had gained through holding classes in childhood development and also by publishing numerous articles and books on the subject, including *Talks with Girls.* She made a name for herself nationally by serving as national superintendent of hygiene and heading up the National Department of Mother's Meetings and Child Care Circles. She was also a founding member of the American Dietetic Association.

While some might think Ella Eaton Kellogg's plate was already piled a little too high, she never shied away from a deep-felt responsibility to take on leadership roles in other issues of the day, both local and national. Some of those were facilitated by her memberships in the Michigan Women's Press Association, American Home Economics Association, the Women's League and the YWCA. Had there been an Overachiever's Association, she would probably have served as its poster child.

Despite spending her entire adult life using her many talents to promote healthful living, Kellogg herself had numerous health issues, including deafness during her later years. Following her death, Alfred University established the Ella Eaton Scholarship in her name.

ANNA HOWARD SHAW

We don't often think of clergy as wild, but the simple truth that the profession was usually closed to women in the early days automatically placed those who persevered among those on the wild side. One of those women was Anna Howard Shaw. Actually, Shaw did it all. She was an England-born reformer, minister and physician. The family left England for Massachusetts in 1851. Anna, one of six children, was just four years old at the time. Eight years later, the Shaw family moved again, this time to 360 acres of wilderness in Michigan.

When she was fifteen, Anna found a job as a schoolteacher and was paid two dollars a week plus board. Later, she went to Big Rapids and lived with one of her sisters. That's when the former teacher finished high school herself. Since childhood, she had nurtured a dream of becoming a minister, but her parents dissuaded her. Somehow she attracted the attention of a Methodist elder who invited her to preach at his church. She must have done a good job because he later asked her to follow him as he made the rounds of his thirty-six-church circuit.

That greatly displeased her Unitarian family, but she refused to give in to their demands. Thus, when she was twenty-four, she was given a license to preach. Being licensed, not ordained, meant she could not serve the sacraments or perform baptisms, but she could and did officiate at weddings and funerals. She soon decided that wasn't enough and enrolled in the seminary at Boston College. In 1880, she became the first woman in the country to become a fully ordained minister in the Methodist Protestant Church.

Eventually, Shaw realized that wasn't enough either. So back to school she went, this time to earn a medical degree. Finally, and perhaps most important to her, she focused on social issues that included suffrage and temperance. She was greatly in demand as a speaker and made a name for herself nationally when she became a close friend and trusted associate of Susan B. Anthony.

During World War I, Shaw served as chair of the Women's Committee of the Council of National Defense. In 1919, that work was recognized when she became the first woman in the country to be awarded the Distinguished Service Medal.

Anna Howard Shaw lived in an era of great social change, and through it all, she soldiered on, making her voice heard and influencing events with her trademark combination of courage and a well-honed sense of humor. That

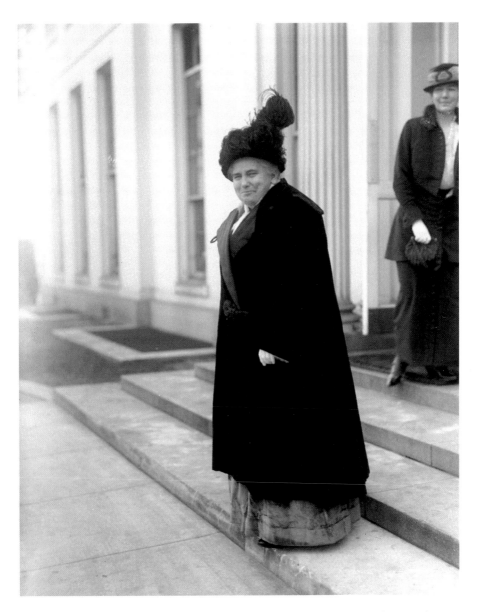

Anna Howard Shaw, known for her work in suffrage and temperance, was also a teacher, minister and doctor. *Library of Congress.*

humor was never more evident than when someone opposed to women's right to vote suggested to her that a woman, being a vain creature, might sell her vote for a new bonnet.

"Perhaps she might, who really knows," Shaw replied. "A new bonnet is a fine thing, and most women would hanker after it. But a good bonnet costs more than a glass of whiskey, and that, they say, is the market price of male votes nowadays."

CAROLINE BARTLETT CRANE

Caroline Bartlett Crane was born in Hudson, Wisconsin, on August 17, 1858, and is remembered for her unrelenting work in urban reform. Her first ambition, like that of Anna Howard Shaw, was to become a minister. Caroline was drawn to the progressive views of the Unitarian Church. Also like Shaw, her family steered her in another direction. After graduation from Carthage College, she taught school in various midwestern cities and also wrote feature articles for newspapers in the Twin Cities, Minneapolis and St. Paul.

One of her reporting assignments was covering a women's rights convention, where she met Shaw and other leaders in the movement, including Susan B. Anthony. Crane became immediately involved in the issue. She figured the best way to pursue that and other social causes she espoused was to disregard her family's opposition and become a Unitarian minister. Her first congregation was in Iowa, but in 1889, she was moved to answer a call to the First Unitarian Church in Kalamazoo, where she would remain for the rest of her life. Over the next five years, she led the church in the direction of responding to the needs of the community at large along with ministering to the members of her flock. She considered the new focus a social reform experiment. To better showcase the change in direction, the congregation changed its name to the People's Church.

Crane's rigorous agenda included kindergarten classes, courses to equip young men with skills needed to get jobs and courses in home management for young women, although that last item doesn't exactly mesh with her women's rights beliefs. She was also a proponent of physical exercise for all. The ever-expanding programs of the Kalamazoo church gained national attention and caught the eye of Dr. Augustus Crane. The couple married on New Year's Eve 1896. Whether she chose the wedding date because it

symbolized new beginnings or not, it was definitely a new path for Crane. Her work had left her without time or energy to master the art of homemaking, and the preacher enrolled herself in some of those classes offered by her own church.

She began taking sociology classes during the summer months at the University of Chicago. The knowledge she gained there catapulted her into her next career: what she called an urban sanitarian. She set her sights on making her hometown, Kalamazoo, cleaner and safer for all its inhabitants. Positive changes she influenced included ensuring the safety of the city's water supply, sewage disposal and a general cleaning up of the city's residential and commercial districts, to name but a few.

It could be said that she made her greatest mark in the area of food safety. With the help of local club women, she unearthed practices in the meat industry alone that were disturbingly similar to what Upton Sinclair exposed in his groundbreaking book *The Jungle*. The Kalamazoo situation was exacerbated by the fact that the city government had no authority to make changes outside the city limits. Crane personally visited every state official who could put new procedures into law. Then she made a study of how other states handled the issue and, with the state attorney general, drew up a bill calling for mandatory inspections. Her unrelenting efforts resulted in new inspection regulations throughout the state of Michigan. To get other women involved, she was one of the co-founders of the Kalamazoo Women's Civic Improvement League.

One thing could be said of Crane: she never rested on her laurels. She pressed forward until meat inspections became national law. Her many achievements in her work led other far-flung municipalities to hire her to do surveys and make recommendations for improvement. Crane's growing reputation soon meant that not only cities but also states wanted to hire her. The first was Kentucky. She at first said no but later capitulated with the stipulation that she would survey only Kentucky towns that invited her. Twelve, including Louisville, extended invitations. She stayed in Kentucky for a little over a month, during which time she made her surveys and gave more than thirty speeches. Her survey was deemed a success, and the entire *Kentucky Medical Journal*'s August 1909 issue was devoted to the work she had done and the resulting changes.

Sometimes called America's Housekeeper, Caroline Bartlett Crane died in the city she loved, Kalamazoo, Michigan, on March 24, 1935, at the age of seventy-seven.

MARGUERITE LOFFT DE ANGELI

Beloved children's author and illustrator Marguerite de Angeli was born in Lapeer on March 14, 1889, to Shadrach and Ruby Lofft. She was their second daughter, and the family later welcomed four boys. Creativity flourished in the Lofft household. Her father was an artist and photographer, and both parents were a bit ahead of the times and believed all children had different gifts and that those gifts should be nurtured. With Marguerite, they must have had a hard time knowing which gift to nurture first, as she grew up to become a professional musician, writer and illustrator.

The music came while she was still in high school. It happened as a fluke when a neighbor heard Marguerite singing while her sister, Nina, played piano. Her lovely contralto voice so impressed the neighbor that she asked her to join a Presbyterian Church quartet, where she would be paid a whopping dollar a week. That was just the beginning. Marguerite studied voice and was soon singing professionally with other choirs.

Music also played an important role in the life of a young man named John Daily de Angeli. The musicians' paths crossed at a choir concert in the Philadelphia suburb of Chester, Pennsylvania. Sparks flew. The initial attraction grew, and they soon became engaged, but before the wedding could take place, Marguerite received what she saw as the opportunity of a lifetime. Oscar Hammerstein invited her to audition at the Philadelphia Opera House, and when she breezed through the audition, he invited her to join his chorus.

It must have seemed like a no-brainer, but there was one pesky little problem: the company would soon begin an extended tour in Europe. Her parents convinced her to refuse the offer, as that tour and the others that would surely follow would place too much stress on the marriage. She put marriage and family first and never looked back.

Soon, motherhood put any other career plans Marguerite de Angeli might have considered on hold—on hold, but never forgotten. While her sons Jack and Arthur napped, their mom studied magazine illustrations. This was in the early 1900s, when artists, not photographers, illustrated magazine stories. De Angeli longed to be an illustrator.

Tragedy struck in 1913. De Angeli gave birth to a daughter, Ruby Catherine, only to lose the child to pneumonia just five months later. The whole family needed a change and moved to Detroit. To help ease her grief, de Angeli began taking art lessons. There she found her life's calling. She began experimenting with watercolors and soon developed ways to work

in the medium that made her illustrations different from those of any other working illustrator of the day.

But instead of plunging headfirst into her newfound talent, real life again got in the way of her dreams and circumstances forced her to postpone her art career—this time for several years. World War I found Dai (her husband went by an abbreviated version of his middle name, Daily) working in a local munitions factory, while Marguerite went to New Jersey to be with Nina. Her beloved sister was dying of tuberculosis.

One good thing happened: Marguerite and Dai discovered they were having another baby. Their joy was short-lived when a particularly vicious influenza strain hit the country hard, and Marguerite became one of the stricken. Despite inadequate hospital care because the outbreak was so severe that most of the nurses had also become patients, she was determined to live. She later said she survived by sheer willpower alone. De Angeli was out of the woods, but what about her unborn child? Fortunately, the baby was unharmed by the flu, and de Angeli gave birth to a daughter she named Nina in memory of her sister.

At last, though it had sometimes seemed it never would, de Angeli's time had come. She could finally launch what would turn into a phenomenally successful children's illustrating and writing career. It began slowly, with illustrations sold here and there. Along the way came two more sons, Ted and Maurice, and both became models for her ever-increasing body of work. Her biggest breakthrough came when she was hired to illustrate a children's book, *Meggie McIntosh*.

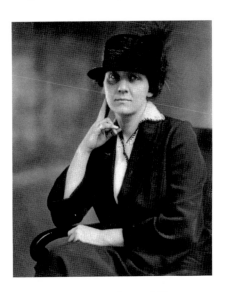

Once again, something beyond her control—the Great Depression—hit the family hard. Dai de Angeli lost his job. Their house was repossessed. Marguerite's work reduced to a trickle, as magazines and children's books were luxuries only a few could still afford. Despite yet another setback, she remained calm and later wrote, "We had health and each other, the same stories to tell, the same music to lift our hearts, and boundless optimism."

Beloved children's author and illustrator Marguerite de Angeli grew up in Lapeer and spent part of her adult life in Michigan as well. *Lapeer District Library.*

Perhaps it was easier to maintain optimism when most of the country was suffering the same fate. In de Angeli's case, the optimism was warranted. She had always wanted to write her own stories, not just illustrate the works of others, and during this time of fewer assignments, she had the time to work toward that goal. One result was her first published book where she was both author and illustrator, *Ted and Nina Go to the Grocery Store*. True, the book would probably garner yawns from later generations of kids growing up on Dr. Seuss, but it broke new ground, as it was the first children's book published in the United States for young children to read on their own. In all, she wrote twenty-eight books and illustrated more.

Marguerite de Angeli went on to write more serious historical children's fiction, including two Amish titles, *Henner's Lydia* and *Yonnie Wondernose*. The latter earned her the prestigious Caldecott Medal for best illustrated book of 1944. She also wrote *Thee Hannah*, about a Quaker girl, and *Up the Hill*, about the experiences of Polish immigrants. *Bright April* received the Lewis Carroll Book Shelf Award in 1946, and in 1950, *The Door in the Wall* won the coveted Newbery Medal. Governor William Milliken honored her in 1979 when he named March 14, 1979, Marguerite de Angeli Day in Michigan. That honor came on her ninetieth birthday. She died in 1987 at age ninety-eight.

Though much of her adult life was lived away from Michigan, both Michigan and Pennsylvania claim her as their own. Lapeer, Michigan, honored its favorite daughter by naming a branch library after her.

FRANCES WUORI JOHNSON MARSHALL

It's easy for those who haven't tried it to think of lighthouse keeping as a dream job. With it comes a room with a magnificent view of sparkling water gently lapping the surrounding rocks. A romantic summer paradise, right? Michigan actually has a few days like that each summer—often very few. The harsh realities of the job included 24/7 hours, physically demanding work, isolation and year-round storms. Storms that pounded, rattled and often damaged the vulnerable lights.

Michigan's extensive shoreline on four of the Great Lakes is probably why it could boast more female lighthouse keepers than any other state. More, but not the first. That honor goes to Hannah Thomas of Massachusetts, who served as her husband's assistant. When he enlisted in the Civil War, Hannah became the keeper.

One of Michigan's most colorful keepers was also the last: Frances Wuori Johnson Marshall. Frances served at the White River Light located between the White River and Lake Michigan from 1944 through 1954. Among other things, she was a strong swimmer and kept in shape by swimming in Lake Michigan. That proved a distinct advantage when she was routinely forced to plunge into the frigid lake to rescue unfortunate (stupid!) tourists who needed saving. Some victims appeared ungrateful, such as the overweight lady who complained that Marshall had hurt her. Marshall claimed the woman resisted her efforts to pull her ashore until the only thing left to do was knock her out. "It was either that or watch you drown," she told the irate woman.

The lady of the lake soldiered on when not one but two husbands deserted her. In 1953, she appeared on the popular TV game show *What's My Line?* Panelists, including Bennett Cerf and Dorothy Kilgallen, never came close to figuring out that she was a lighthouse keeper. For her TV appearance, Marshall received fifty dollars, plus a train trip to New York and a brief stay in the Hotel Edison. The brevity of her city visit can be attributed to the fact that duty called.

Technology ended her career, but something else was lost in the transition. Computers can keep the lights burning to ensure the sailors' safety, but there are no documented cases of a computer diving into a cold lake to rescue someone who should have exercised better judgement. When asked if she missed her job, Marshall said, "You bet! I'd go back in a minute if they'd let me." She enjoyed her administrative job in Montague, but ah, nothing could compare with the romance of the lighthouse.

Julie Belknap Baldwin

Julie Belknap Baldwin considered homemaking a worthy career and pursued it with diligence during her sixty-seven-year marriage. "It's a profession," she said. "You have to work at it."

That philosophy flew in the face of the feminist movement, which, while advocating choice, refused to acknowledge that homemaking qualified as a legitimate profession, even when chosen of a woman's free will. They saw it instead as a fate to escape.

Cadence, the East Grand Rapids local newspaper, quoted Baldwin's advice to younger housewives: feed him well, don't nag and always tell him

how wonderful you think he is. Probably good advice to ensure a peaceful marriage, but wouldn't it have been nice if someone had advised husbands to follow those suggestions as well?

You'd think, after a marriage of that length, she would have retired her apron and settled gracefully into old age after her husband, Melvin, died. Not Belknap. In 1979, at age ninety, the East Grand Rapids resident penned a memoir titled *Never a Dull Moment*, a 225-page hardcover tome that she described as a simple story of two people experiencing sixty-seven years of love and adventure. Two years later, she realized she had more to say and wrote a second book, *There's Life in the Old Girl Yet*. Now there's a role model for those approaching the geriatric stage, and even those who aren't. Julie Belknap Baldwin loved life and lived it to the fullest.

GILDA RADNER

Gilda Radner became known and loved by all who watched the television show *Saturday Night Live*, where she was part of one of the best comedy teams ever assembled that included John Belushi, Jane Curtin and Dan Aykroyd. That led to her induction into the Michigan Women's Hall of Fame as the first electronic entertainment representative. Born in Detroit on June 28, 1946, Radner is remembered as much for her courageous battle with ovarian cancer as she is for her theatrical talent.

Radner graduated from the Liggett School, then an all-girls' school that is now part of Grosse Pointe Woods' University–Liggett School. After graduation, she enrolled at the University of Michigan in Ann Arbor to fulfill her long-held

The irrepressible and still missed Gilda Radner hailed from Detroit. *Michigan Women's Hall of Fame.*

dream of teaching developmentally challenged children. Along the way, she realized that her true passion was performing. After much thought, she dropped out of college in her senior year and moved to Toronto, where she

joined the Not Quite Ready for Prime Time comedy troupe on her way to what would become a successful career in comedy.

Ann Beatts, *Saturday Night Live*'s former head writer, said, "If *Saturday Night Live* was never-never land, Gilda Radner was Tinker Bell." Gilda Radner's zany characters, including Roseanne Rosannadanna, from *SNL* formed the foundation for her one-woman Broadway show, called *Gilda Radner—Live From New York*. As Radner's acting career continued to grow, she starred in movies such as *Hanky Panky* with Gene Wilder, whom she married in 1984.

After Radner was diagnosed with ovarian cancer in 1986, she joined a cancer support group called the Wellness Community of California. She credited the group with giving her the mental and emotional strength to battle the disease, and she became a vocal supporter. Her work made her the inspiration for other cancer support groups that have helped countless other women and their families cope with the diagnosis everyone fears most. Gilda Radner also wrote a book about her battle with the deadly disease, *It's Always Something*. A month before her death in May 1989, she recorded the audio version, for which she received a posthumous Grammy Award.

GILLIAN ANDERSON

When an interviewer asked actor and author Gillian Anderson if she had enjoyed growing up in Grand Rapids, she replied, "Not particularly." While that might not sit well with the locals, one should take into consideration that prior to the family's move to Michigan, she had lived in London. Even the most die-hard Grand Rapids fans can see how their beloved hometown might pale in comparison, probably to the point of making one feel claustrophobic. Gillian explained that she really preferred large cities and proved it by later moving to Vancouver, British Columbia, with her then-husband, Clyde Klotz, and daughter Piper. The couple met on the *X-Files* set, where he was an art director. A Buddhist priest married them in Hawaii on New Year's Day 1994.

But let's hope she has a bit of a soft spot in her heart for the town that led her to an acting career and where she gained her first theatrical experience. She began appearing in school plays in middle school, and by high school, she had starred in and produced a one-act play. Her fate was sealed. After graduation, she enrolled in the Goodman Theater School at DePaul University in Chicago.

Anderson was an unknown when the show's creator, Chris Carter, cast her to play FBI agent Dana Scully on the *X-Files* in 1994. Not everyone agreed with Carter's choice. Some would have preferred the better-known and more glamorous Pamela Anderson, but Carter dug in his heels and insisted Gillian Anderson was the better choice to play the pragmatic scientist. He was proven right when, before the end of the first season, a group of male fans formed an online fan club they named the Gillian Anderson Testosterone Brigade. The club's motto: IDDG (Intellectually Drop Dead Gorgeous). It seems not all the male population is shallow, and some even prefer smart women. As one member said, "We consider her a real woman, not another bimbo chasing after the bad guys while wearing high heels."

She played opposite David Duchovny, who had the role of her partner, Fox Mulder. Viewers sensed a chemistry between them that she discounted as not romantic but, rather, the two reacting to the major differences in their characters. The show's paranormal story lines set Scully up as the skeptic. Her partner is a believer and has to win her over in every episode. It shouldn't have been difficult. After all, they were watching those things unfold; how could they not be real?

In real life, Anderson is convinced paranormal happenings do occur. She also enjoys telling about touring FBI headquarters in preparation for their roles. The agents with whom they met agreed that Gillian Anderson herself, not Dana Scully, might be a good FBI candidate. She says she won't rule it out, as she's always been curious and loves investigating.

The duo had great on-screen chemistry and worked well together. But resentment kicked in when she learned Duchovny's salary was not only greater than hers but she was also expected to stand several feet behind him for photos, never side to side. Understandable in the beginning, perhaps, as his was the bigger name and the industry is notorious for paying men more than women. Anderson demanded and received equal pay after winning Emmy and Golden Globe awards for her role as Scully. That should have solved the problem for good, but when the show was revived in 2016, Anderson was offered only half of what Duchovny would earn. Once again, she had to fight to receive equal pay for equal work.

One issue Anderson remains passionate about is the neurological disease neurofibromatosis. NF, as it's commonly known, is a progressive and incurable genetic defect that can cause disfigurement, learning disabilities, bone abnormalities and brain tumors in severe cases. Her younger brother Aaron was diagnosed with the disease at age three and initially suffered only minor symptoms. Sadly, he died at age thirty of a brain tumor probably

caused by NF. After Aaron's diagnosis, their mother, Rosemary, began running the NF Support Group of West Michigan. Anderson has advocated for research on Capitol Hill.

Today, Gillian Anderson lives once again in London with her daughter and two sons.

The Hollywood career of another Grand Rapids actor is a bit difficult to track, as she worked under three names. She began her career with her given name, Virginia Pound, and appeared in serials. As Lorna Gray, she worked mostly in comedies with the likes of the Three Stooges and Buster Keaton, along with playing opposite John Wayne in *Red River Range*. She left Columbia Pictures in 1945 and forever after was known as Adrian Booth.

Lisa Kelly

If a prize were given to the woman with the wildest job description, it just might go to Lisa Kelly, originally from Grand Rapids. During construction of the Alaska Pipeline, the Dalton Highway was built to move workers, equipment and supplies to Prudhoe Bay. Also known as the Haul Road, it still serves the same purpose. Someone still has to make those deliveries, and adventure-seeking truck drivers are still rising to the challenge. The road starts where the last conventional highway north of Fairbanks ends and courses through the northernmost part of Alaska across terrain so isolated, so rugged, that even most Alaskans never drive it.

The dangerous road and those who drive it caught the attention of the History Channel, and voila! the popular *Ice Road Truckers* reality show came into being. Lisa Kelly, one of the show's early drivers, was an instant favorite, as viewers found it hard to believe anyone could look as gorgeous as she does and do the hard work involved. Photographs of Lisa prove that a woman does not have to sacrifice appearance in the name of performing job duties that would tax anyone, man or woman.

Those who knew Kelly probably weren't surprised when she applied for and got the driving gig. Always up for adventure, some of her favorite activities are snowboarding, horseback riding, skydiving, motorcross and hang gliding. It could be argued that once you've leaped out of an airplane, nothing would ever scare you again, not even driving a ginormous vehicle over one of the most challenging roads in America. She lives in Wasilla, Alaska, with her Aleut native husband, Traves Kelly.

Because Michigan has term limits, career politicians are a rare breed, though some serve in more than one office. Most serve their terms and move on to careers in a different field. Eva Hamilton of Grand Rapids was elected to a seat in the state senate in 1920, and Cora Anderson ran without opposition for the state House, representing the district that included L'Anse.

Evangeline Lamberts became the first woman to hold public office in Grand Rapids following her election as city commissioner in 1961. She forfeited any claim to wildness when her posters referred to her as Mrs. Austen Lamberts. She won the election but served only one term. Early agitators for women in government cleared the path for women like former governor Jennifer Granholm and U.S. senator Debbie Stabenow.

Connie Binsfield, originally from the Detroit area, was the first, and still only, Michigan woman to hold leadership positions in the House, Senate and executive branches of state government. She graduated from Siena Heights College in Adrian and went on to earn her graduate degree at Wayne State University. She, her husband, John, and their five children put down roots in the Traverse Bay area, where she launched her political career as a Leelanau County commissioner. Binsfield was named Michigan's Mother of the Year in 1977. That early honor and her subsequent political endeavors can be seen as proof that, while sometimes contrary to conventional wisdom, a woman can follow her heart and still keep the home fires burning.

Binsfield first entered state politics in 1974 and served eight years in the Michigan House of Representatives. She followed that with winning a seat in the state senate, where she rose to assistant majority leader. Her various contributions to Michigan government included serving or chairing a number of committees on which she left her mark. The short list includes Appropriations, Transportation, National Resources and Environmental Affairs and Tourism. Her last elected role was lieutenant governor for two terms under Governor John Engler in the 1990s. She was the second woman to become lieutenant governor; Martha Griffiths of Romeo, elected in 1982, was the first

Not all Binsfield's work was done as an elected official. President Ronald Reagan appointed her to the North Country Scenic Trails Council. She served tirelessly on the National Park System Advisory Board and as a member of everything from the Traverse Bay Area Women's Republican Club to Zonta International to the Girl Scouts Council. Connie Binsfield's stamp on Michigan will be an enduring legacy.

The Lansing League of Women Voters holding a meeting in 1968. *Grand Rapids Public Library.*

The most recent Michigan woman to serve in the national political arena did not arrive in Washington via the ballot box. President Donald Trump appointed Ada resident and Grand Rapids–area philanthropist Betsy DeVos education secretary, and she was confirmed on February 7, 2017. Her cabinet appointment was the subject of much controversy, as detractors claimed her lack of experience in the public school arena rendered her unqualified. Supporters believe the education system is broken and that a dedicated outsider is the best hope of fixing it.

Despite all these glowing exceptions, women faced resistance when it came to climbing the workplace ladder, in whatever workplace they chose to climb. For one thing, they had the annoying habit of becoming pregnant, thus causing their male bosses problems, though unless he was the father, it's hard to see how it could have affected him too badly. Teachers, for example, had to resign before they showed. After all, in those good old days, children were more innocent, and some might actually believe babies were delivered by storks or dropped in cabbage patches. That applies to city kids; no doubt their country cousins had up-close and personal knowledge of the life cycle and, more importantly, what set the whole thing in motion.

Ruth McArthur recalls working in a department store payroll office in 1960. When she had the audacity to become pregnant, store policy required that at three months, she had to train her replacement and leave. Things didn't progress as smoothly as planned, and the first new hire quit after the first week. It took another three weeks to hire someone else. By that time, McArthur was a bit past four months. Her boss asked her to stay on another two weeks to train the second girl (that's what they called them back in the day), and she agreed. There was just one condition: she would have to wear her raincoat when she walked through the store so she would appear to be a customer and no one would ever suspect the blessed bulge belonged to an employee.

Chapter 3

THOSE ROWDY REFORMERS

My advice to the women's clubs of America
is to raise more hell and fewer dahlias.
—William Allen White (1868–1944)

Some social reformers acted independently. Many others were doing it by committee, as White suggested, but long before he ever thought of suggesting it. They knew that if you want to get a job done, you should organize a women's club to do it. Ladies have always had their literary, garden and other social clubs, but never were they more galvanized than when working for a common cause in which they wholeheartedly believed. Whether suffrage, prohibition, civil rights or the doomed Equal Rights Amendment, they instinctively knew they gained strength in numbers. We can only wonder how many great things have been accomplished because a few women sipped their tea and, while sharing the latest gossip and discussing major issues of the day, eventually turned their attention to smaller, localized needs. When someone lamented the lack of a local library, no doubt someone else said, "Let's form a committee to start one."

The territory's first antislavery organization was the work of Elizabeth Margaret Chandler and Laura Smith Haviland, who formed the Logan Female Anti-Slavery Society in Lenawee County in 1832. Because of their work, Lenawee became an early Underground Railroad stop for runaway slaves on their way to Canada. Chandler was a Quaker originally from Philadelphia whose family had settled in Michigan Territory on a farm near present-day Adrian. Two years later, in an 1834 letter to a Pennsylvania

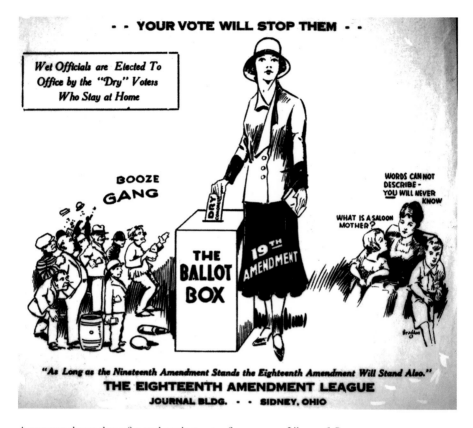

A cartoon shows those for and against votes for women. *Library of Congress.*

relative, she mentioned that the antislavery movement was growing stronger, to the point where it was spoken of in a sermon. "Thee may suppose I listened to this with much glee," she wrote.

Michigan's early suffrage agitators included Clara Bryant Ford, wife of automotive pioneer Henry Ford. She was one of many Michigan women privileged through birth, marriage or both who recognized that not all women shared those perks and only through full participation could they have a say in the issues that determined the quality of their lives. They all shared the opinion of one of their fearless leaders, Susan B. Anthony, who said, "Give to woman the ballot…and she will lift the world into a nobler and purer atmosphere."

Long before Helen Reddy's hit song "I Am Woman, Hear Me Roar" became a mantra to awaken the collective fighting spirit of modern women, their predecessors were already roaring with glee and leaving a trail of

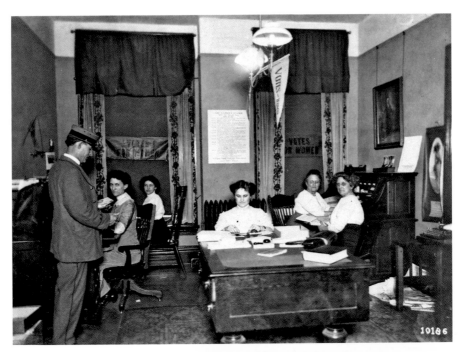

Above: These Grand Rapids women were working hard to pass the Eighteenth Amendment and obtain the right to vote. *Grand Rapids Public Library.*

Right: Besse Morton Garner (*left*), attorney and corresponding secretary of the Michigan chapter of the National Women's Party, on tour with Margaret Whittemore. *Library of Congress.*

usually confused, sometimes amused and often horrified men in their wake. Many of those trailblazers were firmly entrenched in the upper classes, thus having time, disposable income and the social status that gave them a ready platform for espousing their views.

ELIZA SEAMAN LEGGETT

Eliza Seaman Leggett was born in May 1815 in New York City, the daughter of a wealthy doctor. In 1836, she married Augustus Leggett, and the couple set up housekeeping in Roslyn, on Long Island. After relocating to Michigan, they lived first in Pontiac, followed by Clintonville and eventually settled in Detroit. The couple had eleven children.

Leggett had a lifelong passion for improving the lives of society's downtrodden. The first of the many causes she embraced was abolition, and she worked with others in the forefront of the movement, including Lucretia Mott and Sojourner Truth. Her husband supported her efforts, and their home was an early stop on the Underground Railroad. Other abolitionists were frequent guests and, along with Truth and Mott, included Elizabeth Comstock, Laura Smith Haviland and Lyman Beecher. Beecher was the father of Harriet Beecher Stowe, author of *Uncle Tom's Cabin.*

When the Emancipation Proclamation ended slavery, Leggett poured her efforts into the suffrage movement. Using her gifts of speaking and writing persuasively made her a frequent contributor of articles on the topic and a popular figure on the suffrage lecture circuit. But she knew that getting the vote alone wasn't enough. Although it was a start, women had to learn how to advocate for themselves and for one another beyond the ballot box. Toward that end, she co-founded the Young Woman's Home Association for young working women in Detroit.

Eliza Leggett didn't limit her many talents to national issues; she worked on the local scene as well. She helped make sure that the schools and all other public buildings flew the American flag, along with being a booster for the Christopher Columbus holiday. She also ensured that public drinking fountains and horse troughs were placed throughout the city of Detroit.

No detail was too small to escape Leggett's attention if it resulted in making someone's life a bit easier, as evidenced by her convincing the Michigan state legislature to pass a bill requiring shop owners to provide stools behind their counters so employees would no longer be forced to stand

for the duration of their workday. Another achievement on the local front with long-lasting value was turning Belle Isle into a public park that is still enjoyed by Detroiters and visitors today.

Despite her hard work in the community, Leggett always made time for the finer things in life, and one of her pleasures was literature. She carried on a correspondence with some of the day's literary heavyweights, an impressive list that included Louisa May Alcott; Louisa May's father, Bronson Alcott; Walt Whitman; and William Cullen Bryant. To share her love of books and writers, she invited friends to join her in a literary club that eventually grew to become Detroit Women's Club.

Eliza Seaman Leggett died on February 8, 1900, at age eighty-five. A Waterford Township elementary school bears her name.

Elizabeth Comstock

Elizabeth Comstock was born and raised in Great Britain and immigrated to Ontario, Canada. There she met and married John Comstock. The Comstocks moved in 1858 to Rollin, Michigan, and joined the local Quaker congregation. Comstock blossomed in her new community, where it soon became evident she was not only a gifted speaker but a natural-born leader as well. She soon found herself a minister of the Society of Friends.

She had worked hard in Civil War hospitals, doing her best to bring comfort to the patients. After the war, she worked tirelessly to help ease the lives of those dwelling in the so-called contraband camps. Comstock worked to help men and women suffering from the mental and physical anguish the war had caused and what is today recognized as post-traumatic stress syndrome. She helped put into motion the vast relief efforts of the Society of Friends.

Rollin was a stop on the Underground Railroad, and Elizabeth, a passionate abolitionist, threw herself wholeheartedly into the work of helping slaves escape the South. Once the Emancipation Proclamation was signed and the war ended, she continued to help the black race in any way she could but also had more time to take on other causes. Her ability to speak persuasively led her into the front lines in diverse issues such as temperance, peace and women's rights.

Comstock found that working for the rights of prisoners was an area where she could shine. She traveled the country, and by public speaking and

her personal style of compassion, she was able to influence people to treat prisoners humanely no matter how dastardly their crimes. She viewed them as fellow human beings who had gone astray, not as monsters, and thought that while they owed a debt to society, they should be allowed to hold on to some human dignity while paying it.

In 1885, after nearly three decades of calling Michigan home, Comstock retired to Union Springs, New York, where she died six years later on August 3, 1891.

SOJOURNER TRUTH

Not all the early reformers came from a position of wealth and privilege, and the more fervent refused to let those lacks stand in their way. A case could easily be made that no one acted with more fervor than did Sojourner Truth. Certainly no one ever worked harder. When we think of slave owners, we automatically think of southern plantation owners, but in our country's early days, slavery also flourished north of the Mason-Dixon line.

Truth was a former slave who came from extreme poverty. She was born to New York State slaves James and Betsey in 1797. The family belonged to Dutch immigrant Colonel Johannes Hardenbergh, so her first language was Dutch, not English. James and Betsey named their new daughter Isabella. She had many older siblings whom she never knew, as they had been sold at young ages and scattered. She herself was bought and sold at least three times before finally achieving freedom in 1827 when the State of New York abolished slavery.

In June 1843, she moved from New York City to Long Island and renamed herself Sojourner. She adopted Truth as her last name because she planned to wander and speak the truth about the evils of slavery and other social injustices. Not long after that, she relocated again, this time to Battle Creek, the city she would call home for the rest of her life. No matter where else her frequent "sojourns" took her, she always returned to Battle Creek.

Though remembered for her abolitionist work, the reformer was just as dedicated to suffrage. When Harriet Beecher Stowe, author of *Uncle Tom's Cabin*, asked her to speak about women's rights, the popular though uneducated speaker replied, "Well, honey, I's ben der meetins, an harked a good deal. Dey wanted me fur to speak. So I got up. Says I, Sisters, I ain't

Left: President Abraham Lincoln is showing Sojourner Truth a Bible in this painting commemorating their meeting in the White House. *Library of Congress.*

Below: Sojourner Truth was a popular figure on the lecture circuit, and when abolition was accomplished, she turned her attention to women's suffrage. *Library of Congress.*

FREE LECTURE!

SOJOURNER TRUTH,

Who has been a slave in the State of New York, and who has been a Lecturer for the last twenty-three years, whose characteristics have been so vividly portrayed by Mrs. Harriet Beecher Stowe, as the African Sybil, will deliver a lecture upon the present issues of the day,

At On

And will give her experience as a Slave mother and religious woman. She comes highly recommended as a public speaker, having the approval of many thousands who have heard her earnest appeals, among whom are Wendell Phillips, Wm. Lloyd Garrison, and other distinguished men of the nation.

☞ At the close of her discourse she will offer for sale her photograph and a few of her choice songs.

clear what you'd be after. Ef women want any rights mor'n deys got, why don't dey jes' take 'em, an not be talkin' 'bout it?" Amen to that!

October 29, 1864, had to have been one of the proudest moments of her life. On that day, she met President Abraham Lincoln. They expressed admiration for each other's work, and then the president took the little black book she always carried. She recalled the moment later, saying, "He took my little book and with the same hand that signed the death warrant of slavery, wrote, 'For Aunty Sojourner Truth, October 29, 1964, A. Lincoln.'" Artist Franklin C. Courter captured their meeting in his painting *Lincoln Showing Sojourner Truth the Bible Presented Him by the Colored People of Baltimore.*

Sojourner Truth never wavered and continued to fight injustice wherever she saw it. Her entire life was filled with hardships and heartaches sprinkled with the occasional accomplishment and victory that kept her motivated. When she died in Battle Creek at age eighty-six, local citizens collected donations for her grave marker when she was laid to rest at the Oak Hill Cemetery on South Avenue.

One Detroit woman, Nannette Gardner, did exactly as Sojourner Truth suggested and took matters into her own hands. To her it all boiled down to logic. In 1871, the wealthy widow claimed she was a taxpayer, and because she no longer had a man to represent her in political issues, she should have the right to represent herself. City government officials agreed, and Gardner voted in city elections for the rest of her life. She found her sudden fame both funny and a bit annoying and expressed surprise that so simple an act as voting could cause such an uproar when "tens of thousands of vicious, ignorant, and worthless men do the same thing yearly without any comments whatsoever."

Today, protesters have become so commonplace that many ignore them altogether or see their constant presence as gatherings of pests. It wasn't always that way. Back in 1927, it took courage and involved risk to publicly demonstrate. A quartet of Michigan suffragists—Ella H. Aldinger of Lansing; Mrs. G.B. Johnson of Bay City; and Betsy Graves Reyneau and Kathleen McGraw Hendrie, both of Detroit—picketed the White House to draw attention to the movement and were arrested. Reyneau received a prison sentence of sixty days' hard labor.

Grand Rapids women were in the front lines of the war for voting rights, and the state headquarters were located there. One of the rallying cries of the crusading women was a song, "Michigan, My Michigan," that appeared in the *Michigan Suffragist* of December 1914 (author unknown):

A History of Spunk and Tenacity

(Sung to the tune of "O Tannenbaum")

Oh women of the sovereign,
Michigan, my Michigan
Oh rally to emancipate,
Michigan, my Michigan
from worn traditions stale and old,
And limitations manifold
Come sisters, join our Army bold,
Michigan, my Michigan.
From home and shop and college hall,
Michigan, my Michigan
Come work for freedom, one and all,
Michigan, my Michigan
For "Votes for Women" let us stand,
A strong, united fearless band
Until the women of this land,
Sing Michigan, my Michigan.
Since we must all obey the laws,
Michigan, my Michigan,
Though we well know they have their flaws,
Michigan, my Michigan,
Oh let us do the woman's share
To guard our homes from every snare.
To us entrust our children's care,
Michigan, my Michigan.
And if we cannot fight for thee,
Michigan, my Michigan
We bear the men who make thee free,
Michigan, my Michigan
And if we cannot go to war,
The men who do, we suffer for
We, too, have known the veteran's scar
Michigan, my Michigan.
Oh be as just as thou art great,
Michigan, my Michigan.
And let us trim the ship of state
Michigan, my Michigan.
For we would with our brothers stand
And serve and love thee, hand and hand
And make of thee, a glorious land,
Michigan, my Michigan.

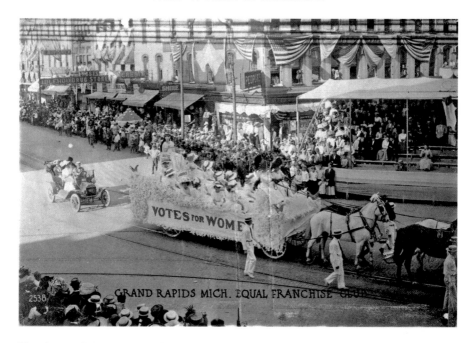

Here is one of the many parade floats demanding votes for women; this one is the Grand Rapids Equal Franchise Club in 1910. *Library of Congress.*

After finally securing the right to vote, these ladies worked to help make sure everyone took advantage of that privilege. *Grand Rapids Public Library.*

Left: Votes for Women was a popular theme, and a good way to draw attention was driving a sporty car decked out for the cause. *Library of Congress.*

Below: Temperance supporters enlisted the help of children to make their opinions on the subject known. *Grand Rapids Public Library.*

The Grand Rapids Prohibition Society and other state groups took up the cause until the Woman's Christian Temperance Union was organized in 1875. Michigan enacted prohibition in July 1919, more than a year ahead of the country, and Grand Rapids women were leaders of the movement. Leaders in the state movement included Lydia M. Boise, who believed her involvement in the issue was a direct call from God and one she was morally obligated to answer. Even those who disagreed on the issue grudgingly respected Boise's heartfelt dedication to end what she regarded as a social evil. The statewide Woman's Christian Temperance Union was formed in

Grand Rapids, and Boise was heavily involved in the formation of more than two thousand WCTUs during the course of her activism. In addition, she advanced the cause through "parlor, pulpit and platform" whenever the opportunity arose. Though she didn't get as much publicity as the axe-wielding proponents of the movement, her way was probably more successful in the long run.

Believers in the evils of alcohol were so adamant that they had no qualms about using children in their attempt to abolish "demon rum" and relied on the image of the stereotypical drunken father and husband who spends his money on booze and fails to provide for his family.

ANNA CLEMENC

By the turn of the twentieth century, the improvement of harsh working conditions was another cause women enthusiastically embraced. Anna Clemenc was born in Calumet, on Michigan's Keweenaw Peninsula, in 1888 to Slovenian immigrants Mary and George Klobuchar. She felt strongly that women had a responsibility to participate in improving the lives of those in the community at large. Her community was Calumet and the Calumet and Hekla Mine, the largest local employer. She advocated for safer working conditions, shorter hours and more pay for the miners and was a leading figure in the famous strike that began in 1913.

At six feet, two inches tall, Clemenc (known as Big Annie) was an imposing figure. She had completed eighth grade, making her better educated than many of her contemporaries, and she considered herself a socialist. Annie believed the only way to achieve justice for the miners was by following the teachings of Mother Mary Harris Jones and Eugene Debs. Her father worked in the mines, and her mother cleaned houses. At age eighteen, she married Joseph Clemenc, a Croatian miner. Not much is known about Joseph. Annie's brother described him as quiet and mild-mannered, which contradicts the fact that she divorced him for wife-beating brought on by his alcoholism.

Nearly three-quarters of the thirteen thousand miners who were members of the Western Federation of Miners in Calumet voted to strike on July 23, 1913. Every day, a parade of sympathizers marched down Calumet's main street, and because she had founded the Women's Auxiliary Number 15, Clemenc marched front and center, always carrying an oversized

Left: One of the early labor activists was Annie Clemenc, who became famous for her work during the 1913 mining strike in Calumet. *Michigan Women's Hall of Fame.*

Below: During the 1937 Fisher Body Plant #3 strike, the UAW Women's Auxiliary served workers food at a restaurant near the factory. *Library of Congress.*

American flag on a ten-foot pole. When asked if she found that tiring, she said, "No, I would support it forever, just as I would my country."

Many of the miners were immigrants and saw striking as the only way out of their impoverished lives. Clemenc agreed. That's why each day her determination won over any fear she might have had for her personal safety, and once again she picked up her flag and marched in solidarity with the striking miners. She was arrested at least twice. On one occasion, she and five other women tried to stop a man they thought was a non-striker from entering the mine. He was, in fact, a deputy, and all five were taken to jail.

Tragedy struck the strikers and supporters on the afternoon of Christmas Eve 1913. Clemenc had hoped to lift sagging spirits by organizing a Christmas party that was held on the second floor of the Italian Hall. In the middle of the festivities, someone yelled "FIRE!" There was no fire, and sixty-nine children and fifteen adults perished in the stairwell while trying to escape. It was thought the person who gave the false alarm was someone who was against the strike, but it couldn't be proven, and no one was ever arrested for the crime.

After nine long months, the strike ended on April 13, 1914, with the miners being granted a pay raise and a shorter workday. Clemenc is remembered for her courage and is considered one of the early leaders in Michigan's labor movement. She was the first woman inducted into the Michigan Woman's Hall of Fame and is one of three women featured on the Hall of Fame medallion, representing women's early struggle for economic justice. The other two are Anna Howard Shaw and Sojourner Truth.

Anna Clemenc went on to marry two more times and had a daughter, but her second and third husbands were also drunks and wife-beaters, so neither marriage lasted. She died in Chicago in 1956 at sixty-eight.

Anna's unflinching courage in Calumet no doubt inspired the next generations of women to fight for the rights of union members.

DOROTHY LEONARD JUDD

Dorothy Leonard Judd could have lived the charmed life of a wealthy socialite but instead spent her entire adult life fighting government corruption. Born into the Leonard Refrigerator family of Grand Rapids in 1898, she graduated from Vassar College and taught high school history and government classes until her marriage. Her husband was local lawyer Siegel

Wright Judd, whose practice eventually became the firm Warner, Norcross, and Judd. The couple had two daughters, Harriette and Dorothy. Then her real work began.

Anyone believing you can't fight city hall had only to look at Judd to see that you really can take on the powers that be, and even more important, you can win. She organized the Citizens' Action movement to rid the city of machine politics. Her impassioned speeches to eager crowds led to a major shakeup in Grand Rapids government when broom-brandishing women demanded a clean sweep of city hall. The end result was the resignation of the mayor and two city commissioners. Another commissioner was recalled. Some thought that not everyone on Judd's black list deserved to be on it, but she did what she set out to do.

Judd didn't stop at city hall and extended her reach to the rest of the state. Most of her considerable influence stemmed from her work with the League of Women Voters. She joined the organization while still at Vassar and over the years held positions of ever-increasing responsibility, the last of which was a three-year term as national director.

Unlike most political agitators, Judd was evenhanded in that she worked to snuff out corruption wherever it took root. Consequently, she earned the respect of governors of both parties. Over a period of nearly thirty years, she was appointed to powerful committees by Governors Brucker, Fitzgerald, Williams and Romney. She refused one request. When Governor Fitzgerald asked her to serve as secretary of Michigan's Civil Service Study Committee, she later said, "I had ideas I wanted to express rather than being merely the recorder of others' ideas."

She did indeed have ideas on that subject, and when she expressed them as a member of the committee, they caused government employment practices to be changed at both the city and state levels. She was one of the authors of a state constitutional amendment in 1939 that created the Michigan Civil Service merit-based system. Judd was one of those people for whom accomplishing one goal propelled her into seeking the next challenge. Election reform was also on her long laundry list of successes. She spearheaded campaigns to change voter registration laws to require more monitoring, thus greatly reducing the number of dead voters and other widespread election atrocities.

Judd was one of the Con-Con 11, a group of five Democratic and six Republican women chosen to attend the 1963 state constitutional convention. The others were Vera Andrus, Port Huron; Ruth Gibson Butler, Houghton; Anne M. Conklin, Livonia; Katherine Moore Cushman,

Mrs. Tierney waves her broom in support of Dorothy Leonard Judd's demand for a clean sweep in Grand Rapids City Hall. *Grand Rapids Public Library.*

Dearborn; Ann Elizabeth Donnelly, Highland Park; Ella Demmink Koeze, Grand Rapids; and Daisy Elizabeth Elliott, Adelaide Julia Hart, Lillian Hatcher and Frances McGowan, all of Detroit. Their participation, including committee assignments, encouraged other women to follow their lead and become active in government. More began running for office, thus giving women more political clout.

Though she must have been asked many times to run for office herself, and was maybe even tempted to do so, Judd resisted. It can be assumed that in her lifelong service in such a wide variety of ways, Dorothy Leonard Judd impacted government to a far greater degree than if she had served in an elective office where one serves a term or two and is promptly forgotten. She died in 1989 at age ninety-one.

Patricia Beeman

Patricia Beeman, of Lansing, accomplished something many dream of but few do. In her obituary, the *Lansing State Journal* stated that "through her unparalleled tenacity, grass-roots organizing skills, and commitment to human rights, Beeman helped shape a new socio-economic policy for Michigan, the U.S., and ultimately the rest of the world." That happened because she recognized and was determined to expose Michigan's involvement with apartheid in South Africa.

She first became aware of the situation through her brother, Rich Houghton, who had been an Episcopal missionary in Namibia. For nearly twenty years beginning in the 1970s, Beeman worked tirelessly as coordinator of the South African Liberation Committee (SALC). Her efforts proved yet again that one highly motivated woman is a force of nature in tearing down the status quo, even when that status quo exists on the other side of the world in a country she has never seen. Along with holding leadership roles in SALC, Beeman and her husband, Harris "Frank," were deeply involved with the Lansing Area Peace Education Center, as well as Michigan State University (MSU), where Frank coached basketball.

Beeman's commitment to end apartheid began in 1978, when she worked with Michigan legislators for passage of several resolutions in support of independence for both Zimbabwe and Namibia. Her talent for working within the system without making waves enabled her to assist in establishing the East Lansing Selective Purchasing Act. She then went on to work with MSU officials in their efforts to become the first major university in the United States to divest funds from corporations operating in South Africa.

In the 1980s, the Michigan legislature passed Public Act 325, which prohibited state funds from being deposited in banks making loans to South Africa. Public Act 512 soon followed. That legislature prohibited state educational institutions from investing in corporations operating in South Africa. One of the many reasons for Beeman's success was that she had the ability to get to the heart of complicated issues and talk about them in a way that average people could understand. Then she took her show on the road and spoke out on injustice of apartheid in any forum she could find to ignite a sense of outrage in her audience.

The arduous campaign worked. East Lansing, MSU and the state of Michigan were among the first in the country and the world to divest

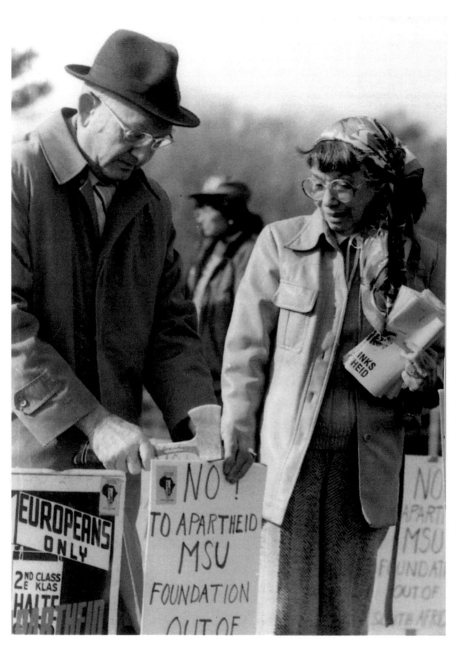

Patricia Beeman and her husband, Frank, worked tirelessly to end apartheid in South Africa. *Michigan Women's Hall of Fame.*

investments in corporations that did business in apartheid South Africa. Patricia Beeman never visited the country for which she had worked so hard and so long, but Frank Beeman traveled to South Africa in 2001, five years after his wife's death in 1996. Frank Beeman died in Flagstaff, Arizona, in 2003.

Elizabeth "Betty" Boomer Ford

Elizabeth Boomer was born in Chicago in 1918, the third child and only daughter of William and Hortense Bloomer. The family moved to Grand Rapids when she was two. She had an idyllic childhood that included summers at a Whitefish Lake cottage. Always outgoing, she was perfectly at ease pilfering goodies from other folks' picnic baskets. She was already chubby, and her mother feared she would become more overweight, so she hung a sign around her daughter's neck reading: Please Don't Feed This Child.

Betty Ford took a giant leap for womankind by going public with her breast cancer diagnosis in 1974. That was back in the dark ages when in polite society, the word "breast" was spoken only when referring to poultry entrées. It took tremendous courage on her part for that and another reason: apart from the delicacy of the subject, her husband, Gerald R. Ford, was president of the United States. Everything she did reflected on him.

First ladies were expected to have causes, as long as they were in no way controversial, such as Lady Bird Johnson's highway beautification project, Nancy Reagan's "Just say no" approach to drug use and Barbara Bush's work toward literacy. One exception was Eleanor Roosevelt, who preceded Betty Ford by decades. Roosevelt was no shrinking violet when it came to controversy and clearly had her own agendas, so while she was widely admired, she was widely vilified as well. Most presidents' wives played nice and stayed in the background. First ladies were discouraged from making waves.

Ford had issues she cared about, some of which were controversial, and though she preferred her private life remain private, her earlier life made her comfortable being in the limelight. Young Betty Bloomer had dreamed of dancing professionally and had, in fact, spent time on stage in New York. Before that, she modeled teen clothing at Herpolshimer's Department Store. That never got in the way of her daily dance lessons, and she even found time to teach dancing to younger kids in the neighborhood.

Following graduation from Central High School, she moved first to Vermont to study dance and then to New York, where she furthered her studies with the Martha Graham dance troupe. She found opportunities to dance and supplemented her performing income with modeling jobs. Ford's mother was less than thrilled and coaxed her daughter to come home for six months, and then, if she still wanted a career in dance, she would back her 100 percent. Once back in Michigan, she worked at Herpolshimer's as the fashion coordinator's assistant. Unable to completely turn her back on her first love, she taught dance and started a local troupe. She married Gerald Ford in 1948 and, a few weeks after the wedding, moved with him to Washington when he won his first term as a congressman representing Michigan's third district. The couple had four children: sons, Michael, Jack and Steven and daughter Susan.

Fast-forward to 1974, when she announced she had breast cancer. She had already shocked the country when she said that, unlike previous presidential couples, she and Jerry would share a bedroom—and a bed! The media called her disgraceful. Surprisingly, when it came to her cancer, that same media, instead of berating her, applauded her candor in placing the spotlight on the once unmentionable disease and credited her with saving countless other women's lives.

One of those women was Margaretta "Happy" Rockefeller, wife of Vice President Nelson Rockefeller. Happy Rockefeller was tested for breast cancer just weeks after Betty Ford's disclosure and was diagnosed with cancer in both breasts. She underwent a double mastectomy and lived until 2015.

The candor that propelled Betty into publicizing her cancer also led her to be vocal about other issues in which she strongly believed. One of those issues was the Equal Rights Amendment in 1975. She was an outspoken proponent, and though she worked tirelessly toward its ratification, the amendment was defeated. Betty's support of abortion rights and of not condemning people for being less than perfect caused dismay in some circles, but eventually she became so popular that "I Want Betty's Husband for President" buttons were a hot 1976 campaign seller. Remember, this was a kinder time in political history, before partisan my-way-or-the-highway singlemindedness took over. There was still time for compromise, and opinions that flew in the face of the so-called party line weren't automatically deal breakers.

Ford followed that up with not hiding her addictions and founding the Betty Ford Clinic in Rancho Mirage, California. The clinic, now affiliated with Hazelden, is still going strong with multiple locations, and it would be difficult to estimate the number of lives it has transformed. And all because

one bold woman had the courage to tell the truth and, in so doing, change the futures of countless other troubled people.

She not only founded the Betty Ford Clinic but also ran it until 2005, when she stepped down, accepting the role of chairman emeritus, and turned the reins over to her daughter, Susan Ford Bales. After Betty's death, an internal power struggle removed Susan from the board. Betty Ford died in 2011 in Rancho Mirage. She was ninety-three.

The Mary Free Bed Guild

A few compassionate Grand Rapids women saw a need and filled it, and the end result turned into the Mary Free Bed Hospital and Rehabilitation Center, a nationally renowned facility. It all started because in the days before health insurance, not all could afford the care they needed, especially during hard economic times. Especially hard hit were immigrants flocking to the city in hopes of achieving the American dream via employment in the burgeoning furniture industry. Many did in fact prosper, but they usually had to settle for low-paying jobs and cramped living quarters while on the ladder's lower rungs.

That changed one day when someone found a small purse containing six pennies. Even back in 1891, a penny could only stretch so far. The finder suddenly had a vision of mounds of pennies. Even among those with good jobs, few could afford large donations, no matter how worthy a cause. But a few pennies here and there? Yes! Mary was one of the most popular women's names at the time. It seemed as if everyone was a Mary, related to a Mary or, at the very least, knew some Marys. A group of women collected money from all who were willing to make a contribution, no matter how small, in honor of someone named Mary.

Money, sometimes only pennies, poured in. It was not enough to fund a charitable hospital but enough to pay for a "Mary Free Bed" to be reserved for someone in need at the hospital, then called the Union Benevolent Association Hospital. The hospital later became Blodgett Memorial and is now the Blodgett Campus of Spectrum Hospital.

That was just the beginning. An army of volunteers, calling themselves the Mary Guild, made sure the project grew. They acquired a vehicle, named it Mary and used it for transporting patients to and from treatment. Out of one modest bed came the Children's Convalescent Home. By 1937, the name

had become the Mary Free Bed Guild Convalescent Home and Orthopedic Center. The timing was right for the facility to provide groundbreaking care to victims of the polio epidemic.

With polio eradicated, it now serves those needing short-term rehabilitation from surgeries, including hip and knee replacements. More importantly, it is a nationally renowned facility treating spinal cord injury and major stroke patients.

The name is unchanged, though the beds are no longer free—a nice tribute to all the generous people who united to help those in need and did so in honor of someone named Mary.

These weren't the only Marys who had a major impact on healthcare in Grand Rapids. Three Sisters of Mercy nuns founded St. Mary's Hospital there in 1901. Sister Mary Ignatius McCord, Sister Mary Anthony McMullen and Sister Mary Baptist Feldner didn't administer the hospital from plush offices; these women not only nursed their patients but also stirred the soup and scrubbed the floors.

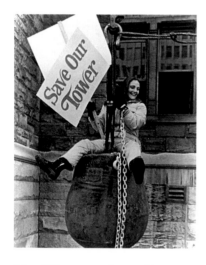

Mary Stiles mounted a wrecking ball in what turned out to be a futile attempt to stop the razing of the old city hall building in Grand Rapids. *Grand Rapids Public Library.*

Every city can boast some women who actively worked to improve their surroundings in smaller but meaningful ways. Grand Rapids' list would have to include Nancy Mulnix Tweddale and Mary Ann Keeler, whose untiring efforts made the Alexander Calder stabile *La Grande Vitesse* (The Grand Swiftness) a reality. Barbara Roelofs led the crusade that saved so many Heritage Hill architectural gems from the wrecking ball.

And speaking of wrecking balls, Mary Stiles actually did look a bit wild when she mounted one in a last-ditch though unsuccessful attempt to stop the demolition of the old city hall. She knew the building was doomed but hoped the resulting publicity would call attention to the need to save the city's architectural treasures and make the movers and shakers stop and think before destroying any more historic landmarks.

Waunetta McClellan Dominic

A century after another Ottawa woman, Madame LaFramboise, left her mark on the state, Waunetta McClellan Dominic rose to prominence as an advocate of tribal justice and spent most of her life also endeavoring to improve the lives of her people. The Ottawas, also called the Odawa, were one of the tribes of the *Anishnabek*, which translates to Good People. Waunetta was born in Petoskey in 1921. Petoskey, on Lake Michigan, is about thirty-six miles and a ferry ride west of Mackinac Island, Madame LaFramboise's home.

With her husband, Robert Dominic; father, Levi McClellan; and two other men, Waunetta co-founded the Northern Michigan Ottawa Association (NMOA). One of the group's actions was filing lawsuits to make sure the northern Michigan natives received a fair settlement for land that had been taken from them for which they were paid less than 13 percent of its actual value. That land included most of northern Michigan. NMOA was formed in 1948, more than a century after the Ottawa and Chippewa peoples were cheated in the treaties of 1821 and 1836.

Making that happen required that Dominic travel the state conducting massive research that would daunt a lesser woman. First she had to locate the descendants of the tribal members who had signed the treaties and persuade them to become part of the litigation. Then she had to come up with reasonable estimates of the value of those lands at the time the treaties were signed.

It was not until 1968 that Waunetta and Robert Dominic filed the land claim suits that resulted in a judgement of more than $12 million to Ottawa and Chippewa descendants of the 1836 treaty signatories. And that wasn't all. Another $900,000 was awarded in 1971 to the descendants of those who signed the treaty of 1821. As a member of the Grand River Band of Ottawas, she fought to win the payment of $1.8 million for land claims on behalf of 2,800 non-reservation Ottawa and Pottawatomie tribal members.

One of Dominic's favorite responsibilities was working with young people and motivating them to not settle for less than they were capable of achieving. She not only urged them to go to college, she also helped them apply for grants and find funding to make it possible. She reminded them to take pride in their roots. As she put it, "You must live in two worlds. Education and keeping up with the times can, and must be, combined with studying Indian history, art and language."

Waunetta McClellan Dominic's tireless work instilled new hope in the native communities throughout the state but nowhere more than in her beloved Petoskey. She continually stressed the need for the next generation to learn and embrace technology. Another issue to which she gave her considerable influence was in the establishment of technical and trade training programs to ensure the up-and-coming tribal members had adequate preparation to assume their rightful place in the workforce. Her work in both the Crooked Tree Arts Council and the Christian Life Center of Petoskey further inspired cultural pride among her people. Dominic's lifelong efforts can be seen as a model for not just ethnic equality but win-win solutions to tensions that can often be divisive.

"You can call us unrecognized, but don't call us unorganized, and furthermore, I don't care if you recognize me or not," she said. "Recognize my rights."

Dominic's father-in-law, also named Robert, served as president of NOMA for more than twenty-seven years. Following his death in 1976, she was elected to take his place, a position she filled from 1976 until her death in 1981.

EDELMIRA LOPEZ

Edelmira Lopez created venues for the Latino community to celebrate their heritage and to increase the awareness and appreciation of Hispanic culture for Michigan citizens. In 1961, after seeing a need for religious services in Spanish, Lopez helped found the Cristo Rey Church in Lansing. Later, she worked as a founder of the Cristo Rey Community Center in Lansing to help see to the social needs of the community. She served as the chair of the board of directors for the center for over twenty years. Through her work, thousands of Michigan citizens continue to receive direct assistance with housing, food, healthcare, senior services, legal services, job training, counseling and more.

In addition, Lopez worked on the local team of the United Farm Workers, taking part in activities that supported the rights of farmworkers in this state and country. She played an integral part in Cesar Chavez's visits to the Lansing area by arranging and promoting events for Chavez and his team.

As the first female president of the Lansing Mexican Patriotic Committee and president of the Hispanic Cultural Center, she organized many cultural events. In 1973, Lopez became the first Latina on the City of

Edelmira Lopez worked to instill pride in the Latino community through education and awareness of its rich heritage. *Michigan Women's Hall of Fame.*

Lansing Housing Commission. She served the commission for twenty-five years, sixteen of them as chairperson. Her community work has been recognized in newspaper and magazine articles, television programs, government proclamations and awards, including the YWCA Diana Award in 2003. Lopez's courage, tenacity and dedication overcame racism and sexism, making her a voice for the underprivileged and a catalyst for the betterment of the community.

Another Latino woman had an agenda and didn't shy away from making things happen, even if it involved the heads of two countries. Delia Villegas Vorhauer's civic involvement began when Governor William Milliken appointed her to the Michigan Women's Commission. From that beginning, she went on to serve in other ways, including time with the Michigan Coalition of Concerned Hispanics.

When her daughter suffered from mental illness, Vorhauer became an active member of the state chapter of the Alliance for the Mentally Ill. That led to writing two guides for families facing the challenge and later to the development of a training program for law enforcement personnel dealing with the issue. Vorhauer's greatest accomplishment was serving as co-coordinator of Women for Meaningful Summits, which helped various women's groups identify major issues, including mental illness, for discussion in a meeting between President George H.W. Bush and Russian president Mikhail Gorbachev.

Viola Liuzzo

Viola Fauver Gregg Liuzzo was born in 1925 in Pennsylvania and raised in the South but later moved to Detroit. There, she felt compelled to join the struggle for civil rights and had joined the local chapter of the National Association for the Advancement of Colored People by 1943.

A 1910 letter from Frances E. Mueller of the Consumers League to a Mr. Tolbert asking for his support in fighting inflation at a Wayne State University meeting. *Library of Congress.*

During the 1960s civil unrest, she was a pre-nursing student at Wayne State University and marched in the 1964 Civil Rights March in Detroit. Viola heard Dr. Martin Luther King Jr. perfect his "I Have a Dream" speech at Cobo Hall. His call to action, coupled with the news of "Bloody Sunday" in Selma, Alabama, propelled her to travel to Alabama and volunteer for the Southern Christian Leadership Conference.

On March 25, 1965, Liuzzo marched from Selma to Montgomery with twenty-five thousand others led by Dr. King. That night while driving her car with Leroy Moton, a young African American civil rights activist, she was gunned down by four members of the Ku Klux Klan. She tried in vain to outrun them, all the while singing "We Shall Overcome," but witnesses said the assassins pulled up beside her car and then fatally shot her. She died instantly, the ultimate sacrifice for a cause in which she wholeheartedly believed. Her passenger, Leroy Moton, wasn't injured.

President Lyndon Baines Johnson, in a call to Liuzzo's husband, Anthony, said, "I don't think she died in vain because this is going to be a battle all out as far as I'm concerned." Though some tried to downplay her death up to the point of blaming the victim, historians credit Viola Liuzzo's murder as the defining moment for the passage of the Nationwide Voting Rights Act of 1965. Previously, the act had stalled in Congress.

Her family members report she was someone who never shied away from following her conscience, even if it involved risking her personal safety, and she encouraged them to do the same.

Abolition, suffrage, temperance and civil rights were not the only issues women worked to reform. They rallied in large numbers to the cause of consumer protection as well. The Consumer Protection League was formed in 1891 for the dual purposes of advocating for consumers and ending workplace exploitation. In 1910, Frances E. Mueller wrote to a Mr. Tolbert on league stationery to enlist his help in spreading the word of an upcoming meeting to be held at Wayne State University in Detroit. She hoped for large attendance as they discussed the urgent problem of inflation.

Chapter 4

UNCLE SAM WANTED HER

A woman is like a teabag—only in hot water do you realize how strong she is.
—Nancy Reagan, Observer, *March 29, 1981*

PAULINE CUSHMAN

Pauline Cushman distinguished herself as a Civil War spy and earned the rank of major, signed by President Abraham Lincoln for "deeds of daring."

Her early life as a New Orleans belle seemed an unlikely background to foster a woman of her courage. Young and beautiful, she was pampered and protected by a loving family and probably broke more than a few suitors' hearts. The family moved to Grand Rapids, where an adventurous spirit caused her to rebel against parental authority. The headstrong young lady defied her family and became an actress.

That career took her to the South after the war was declared. She played up her southern roots and charmed all those she encountered, all the while making a good living and enjoying her ever-increasing theatrical popularity. Then she made an abrupt change and decided her destiny would be serving the Union as a spy and scout. While performing in *Seven Sisters*, in Louisville, she accepted a dare to raise a toast to Jefferson Davis during one of her scenes. When the moment arrived, she raised her glass and ad-libbed, "Here's to Jefferson and the Southern Confederacy. May the South always maintain her honor and her rights."

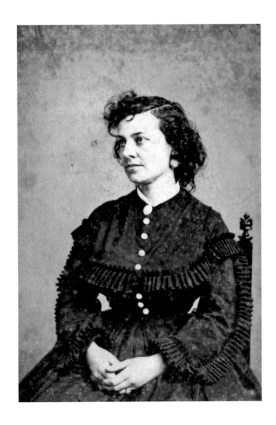

Pauline Cushman used her acting talent to act as a spy for the Union forces during the Civil War. *Library of Congress.*

Cushman was fired, of course, but the citizens of Kentucky rallied around their new-found heroine, and her charm and popularity made her privy to sensitive information that she passed on to Union higher-ups. No one suspected that before the theatrical Jefferson Davis toast, she had gained the confidence of Colonel Moore, provost marshal of the district, and had pledged her oath of allegiance to the United States and was by then a member of the secret service.

Her stage experience had taught her to use makeup and disguises as well as how to portray a broad range of characters. This enabled her to freely move about as a country bumpkin, a Confederate soldier on leave, an old woman and a young Southern lady. She learned secrets of the guerrillas and reported them.

She had many narrow escapes but only once found herself in mortal danger when she was captured and accused (correctly!) of spying. Her captors delivered her to General Braxton Bragg, who tried her via court-martial and found her guilty. Her sentence: hanging. The execution was postponed when Cushman became ill. As soon as she realized sickness

was saving her life, her condition worsened. Before she could "recover" sufficiently to hang, she was rescued by General William Starke Rosecrans's advance troops.

Though she was wounded twice, she continued to serve valiantly until the end of the war. When discharged, Pauline Cushman received the honorary rank of major and was given a full military funeral, complete with "Taps" and flag-draped coffin, when she died in San Francisco in December 1893.

SARAH EMMA EDMUNDS

During the Civil War, it's estimated that more than four hundred women joined the Union troops by posing as men. They pulled this off in part because physical examinations weren't routinely done. When it came to mundane activities like bathroom usage, they either waited until the latrines were unoccupied or simply slipped into woods or other discreet locations. They waited until dark to bathe in creeks. One of those good soldiers was Sarah Emma Edmunds. Of course, no one knew her as Sarah because she had donned men's clothing and enlisted as Frank Thompson.

Edmunds was born in New Brunswick, Canada, but was living in Flint, Michigan, when the war broke out. From childhood on, Emma, as she preferred to be called, never let the fact that she was a girl keep her from doing hard work. As the youngest of five children on a farm, Edmunds, along with her siblings, took care of the farm animals, chopped wood and grew into an excellent equestrian. Edmunds left Canada in search of greater opportunities and, in Flint, took a job selling religious books door to door. Women didn't do that sort of work in 1859, so she dressed in men's clothing and adopted the name Frank Thompson.

Two years later, Private Franklin Thompson joined Company F of the Second Michigan Infantry. Edmunds's early farm life enabled her to breeze through the strenuous basic training. No one ever suspected she was a woman, though she often found herself the butt of jokes about her "ridiculously small boots."

At that time, military nurses were men. Edmunds served as a nurse and also as a road construction worker and guard. Like most of the women attracted to such a life, she had a low tolerance for boredom and a well-developed sense of adventure.

Because she had enlisted and served under a false identity, it was difficult for Edmunds to gain much-deserved credit for her military service. Eventually, her exploits were proven, and she was given the credit due. She became one of only 2 women known to have been members of the Grand Army of the Republic at a time when women were only allowed membership in the auxiliary organization. The other was Kady Brownell of Rhode Island. The Grand Army of the Republic was a fraternal organization made up of men who had served in the Union army during the Civil War. Members supported, among other things, voting rights for blacks, pensions for veterans and the creation of Memorial Day as a national holiday. At one time, there were 490,000 members—399,998 men, Sarah Emma Edmunds and Kady Brownell.

Edmunds died on September 5, 1898, and was given a funeral with full military honors.

Between the Civil War and World War I, the Spanish-American War raged. Ellen May Tower of Byron, in 1898, became the first U.S. Army nurse to die on foreign soil when she died, not of war wounds, but of typhoid fever while serving in Puerto Rico. She received a full military funeral back home in Michigan.

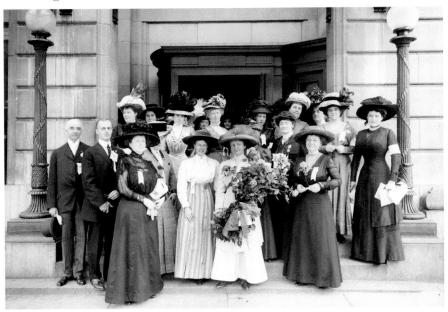

Blue Star Day in 1906 shows two men and two women honorees. *Bentley Historical Library, University of Michigan.*

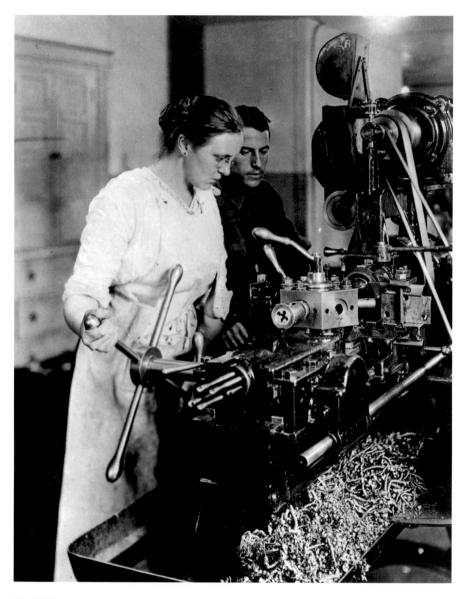

World War I also brought women out of their homes and into the factories, like this one working with a turret lathe in 1914. *Library of Congress.*

When the United States entered World War I in 1917, women lined up to do their part. Some joined the military while others worked in factories to help the effort. Patriotism ran high, and all wanted to participate in what was mistakenly thought to be the "war that would end all wars."

Rebecca Shelley

Not all women involved in war efforts served. Some tried to stop wars. One of those was Rebecca Shelley of Battle Creek, who joined pacifists in an attempt to stop World War I. Instead of being touted as a heroine, most called her actions treason. She stated:

> *I believe that God has laid his hand upon me and is leading me to help bring about peace. Really, the matter is very simple. All the countries realize that the war is futile and are anxious for the chance to stop without seeming beaten. But Americans either don't believe it, or they want to keep up the war in order to continue their profits. Now the thing for us to do is make some influential man like [Henry] Ford see that our government takes the first step in the mediation. Mr. Ford's secretary said that he would believe in the plan if I got certain statements from Count [Johann-Heinrich] von Bernstroff [the German ambassador]. Well, I got those statements, and now it is only a question of time till I can see Mr. Ford. I have also interviewed one Englishman of note, as well of those people as an equally noted Englishwoman. And what they, especially the latter, told me almost makes my spirit fly out of my body. We have the blood of those people on our hands. We are the only neutral nation which is holding back from mediation. You see, it isn't enough to offer—we must call together the council of neutrals, and make definite propositions, and then the belligerents can accept without seeming to be beaten.*

Shelley's fiancé enlisted when the United States entered the war in April 1917. He died of encephalitis before it was over. She lost her U.S. citizenship from 1922 to 1944 for marrying another German and then refusing to take a naturalization oath that required her to bear arms to defend the United States.

Rosie the Riveter

World War I ended, but the "end all wars" promise didn't hold true. Adolph Hitler seized control of Germany, and Germany, along with Italy and Japan, waged war on the free world. The United States was forced to become involved when Japan attacked Pearl Harbor. That we were attacked on our own soil brought patriotism to a fever pitch.

Her name probably wasn't Rosie, but the woman in the foreground is riveting during the World War II years. *Library of Congress.*

Men joined the armed forces in droves. The demand for the production of goods needed for the war effort—including, among other items, aircraft—skyrocketed at exactly the same time men who had formerly worked in factories were now overseas fighting the enemy. Someone had to fill those orders. Women enthusiastically rose to the challenge. On the homefront, Rosies riveted, while all across the state, women tended victory gardens and managed to feed their families and otherwise get by on whatever their ration books allowed them to buy.

Rosie the Riveter became a World War II symbol, and the real Rosie is Michigan's own Rose Will Monroe of Ypsilanti, who posed for the iconic "We Can Do It" poster. Monroe's husband had died in an auto accident, leaving behind an attractive young widow with two children she supported by working as a riveter in Ford Motor Company's Willow Run plant.

To cope with the shortage of manpower, the government planned an advertising campaign to lure women out of their homes and into the workforce. The idea was to appeal to their patriotism. Bandleader Kay Kyser had recorded a popular song titled "Rosie the Riveter," and coincidentally, Hollywood celebrities like Walter Pidgeon toured the country encouraging one and all to buy war bonds. Bonds were directly related to the workplace problem, as building bombers required a great deal of cash. Pidgeon happened to tour the Willow Run facility and met Rose Will Monroe. As the cliché goes, the rest is history.

Monroe, soon recognized by all as Rosie the Riveter, not only served her country by working in the Willow Run factory but also inspired countless other women across the country to take on factory jobs and do the work

needed. Their devotion to duty helped secure the ultimate victory for the United States and its allies.

The problem of what to do when the war ended, as some of those same women had gotten a taste of independence and didn't want to leave their jobs and their wages, estimated at around $2,000 per year, was an issue no one saw coming. Not all women wanted to retire their lunchboxes and return to the kitchen, thus spawning the phenomenon of families with two wage earners. The postwar economic boom coupled with double paychecks fueled suburban growth and a new style of living.

For some women, serving in various capacities at home simply wasn't enough. They lined up to join the army's women's branch, the Women's Army Corps. There is evidence that they endured the same rigors as the men. Anna Moore, a Detroit librarian, wrote to friends of being kept so busy that she was often unable to follow basic army standards of cleanliness. She said she seldom even had time to wash her hands between six o'clock

In 1943, a Women's Army Corps recruiter signs up students at the University of Michigan in Ann Arbor. *Bentley Historical Library, University of Michigan.*

Left: Elsie Terry, shown using a precision snap gauge during one of the steps in manufacturing guns at the A.C. Spark Plug factory in World War II. *Library of Congress.*

Below: The Base Hospital Unit posed at the University of Michigan hospital before leaving for active World War II duty in 1942. *Bentley Historical Library, University of Michigan.*

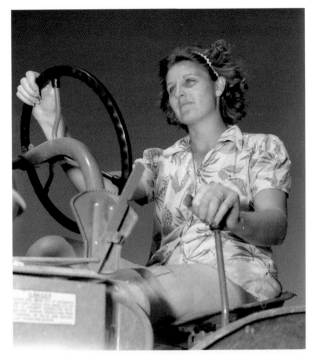

Right: Some women, like Mrs. Wood, shown here, didn't work in factories during wars; they took over their husband's jobs of farm management. *Library of Congress.*

Below: An ordnance worker is performing one of the steps involved in making 105mm shell casings in the Budd factory. *Library of Congress.*

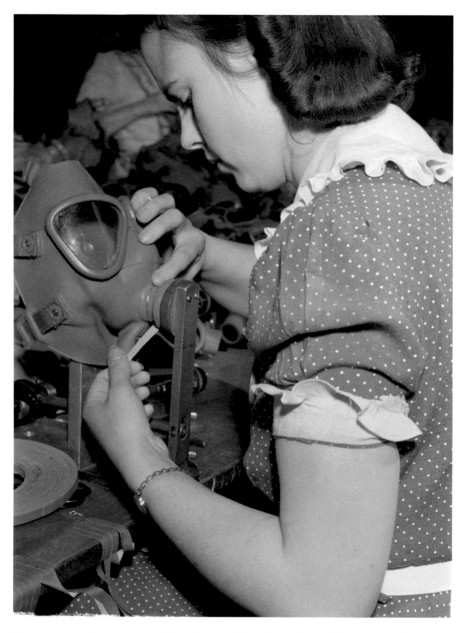

Women across the state entered factories to produce the goods needed to support the war effort in the 1940s, like this one working on a gas mask. *Library of Congress.*

in the morning and six o'clock in the evening. As she put it, "Every time I get near a washroom, someone blows a whistle and we have to fall in somewhere else."

Moore's innate sense of humor obviously helped her through some of the most frustrating times. She wrote that life wasn't too complicated. The army made the rules, and the WACs followed them: "The whole thing is accepting it as such and not kicking against the obvious stupidities." The words of a woman who quickly learned the secret to getting along in many of life's situations. She found the food better than she thought it would be, but there were no tablecloths or amenities. She hadn't expected them and therefore was not disappointed when she didn't get them.

Marion "Babe" Weyant Ruth

Michigan had its own Babe Ruth, and she didn't play baseball. From childhood on, her life revolved around flight. While other girls were busy doing the usual girlie-girl things, Babe hung out at the Lansing airport watching planes and collecting pilots' autographs. One autograph was from Amelia Earhart, who encouraged the young girl to follow her dream. She didn't need to be told twice.

Over the next years, she advanced from earning an amateur's license all the way up to commercial and instrument ratings and spent a number of years working as a flight instructor, one of only a handful of women to do so during the early days of flight. During World War II, that work led to her stint as a civilian instructor teaching instrument flying to military pilots.

Ruth accumulated more than ten thousand flying hours and took on projects such as accident prevention counselor for the Federal Aviation Association, as well as volunteering to teach flight safety to the Michigan State Police and other agencies.

Her vocation was also her avocation. Ruth spent her free time racing against competitors who were mostly men and also flew in air shows and powder puff derbies. She was an avid aviation historian and lifelong collector of aviation-related memorabilia.

In nearly sixty years of flying, Ruth accumulated numerous awards. She was the second woman inducted into the Michigan Aviation Hall of Fame. You will also find her in the Michigan Women's Hall of Fame, the Michigan Sports Hall of Fame (the first aviator so honored) and the OX-5 Aviation

Pioneers Hall of Fame. The OX-5 was an engine designed by the Curtiss Company. Ruth was one of only sixteen women recognized in 1940 by the American Certified Airmen.

NANCY HARKNESS LOVE

Women didn't just serve on the ground; they took to the skies as well. Nancy Harkness Love had her first flying experience at age twelve when a barnstormer took her for a ride. The first ride only made her want more, so she paid the pilot to take her up again. By the third flight, she was hooked. She later told *Michigan History* magazine, "You know how it is. You look at a horse and think 'I'd like to ride one.' Well, I guess I just looked at that barnstormer's airplane, and said to myself, 'I'd like to fly one.'"

Hannah (nicknamed Nancy) Lincoln Harkness was born in 1914 in the Upper Peninsula copper-mining city of Houghton. Her father was a doctor, not a miner, so her wealthy parents sent her a private school in Milton, Massachusetts. Two later events cemented her fascination with aviation. The next year, she spent the summer traveling in Europe with an aunt and cousin. She was at the Paris airport when Charles Lindbergh arrived. No ordinary arrival, it was the finish of the historic flight that made him the first person to solo nonstop across the Atlantic Ocean. A year later, the then fourteen-year-old Nancy eagerly followed reports of Amelia Earhart when she became the first woman to cross the Atlantic.

Her parents were less than enthusiastic when she told them she wanted to take flying lessons. Love's father was afraid his impulsive daughter would quit school. Her mother found the whole idea of flying machines frightening in the extreme. Eventually, a compromise was negotiated. Her parents agreed to allow her to take flying lessons for the rest of the summer, but only if she promised to go back to Milton when the new school year began. She later said her father also told her, "Do it well or not at all." Love was sixteen when she earned her pilot's license in 1930, then the youngest person, man or woman, to hold that distinction. Two years later, she earned a commercial license.

She continued her flying lessons even during her first year at Vassar College, something that no doubt separated her from the rest of the pack. She was known as the "Flying Freshman."

In the late 1930s, Love convinced the powers that be that women pilots were every bit as capable as men of taking on dangerous assignments. She

campaigned for, and won, the job of test pilot for the Gwinn Air Company. Part of her job description was performing extensive testing of landing gear, especially that of the three-wheeled, known as "tricycle" gear. Though she loved what she was doing, it was more than a grand adventure. When the Depression greatly reduced her family's wealth, Love had to drop out of Vassar College. She supported herself by working as a test pilot.

World War II and the days leading up to it was an aviation game changer. The ever-increasing need for aircraft on the European front produced a growing need for pilots as well. For Love, the solution was simple. Why couldn't women fly the planes from the factories producing them to the military bases where they were needed? A logical idea to be sure, but even then the military didn't always act on logic. One issue that seems silly in retrospect was that some officers were superstitious and believed utilizing female pilots would bring them bad luck. After much resistance, her plan was put into action in 1942.

Her reputation made her the logical choice to command those women, not to mention that it was her idea in the first place. She and her pilots were named the WAFS (Women's Auxiliary Ferry Pilots), later called the WASP (Women's Airforce Service Pilots).

According to Love's biographical information at the Michigan Women's Hall of Fame, the women operated under stricter standards than their male counterparts:

> *Love and her women pilots had an uphill battle to be accepted. While men recruited from civilian life could be from 19–45, women pilots had to be between the ages of 21 and 35. Women had to have a high school diploma, but men only needed three years. Male pilots flying requirements were reduced to 200 hours of flying, down from an original 300 hours. Women, on the other hand, were required to have a minimum of 500 hours. In spite of all of these requirements women were allowed to fly only the smallest trainer and liaison airplanes. Additionally, men could get a commission after a 90-day training period; women however remained civilians. Having proved their skill, WASPS later flew the fastest and the largest fighter planes in the world.*

After the war, Nancy and Robert Love raised three daughters.

ALEDA LUTZ

Aleda E. Lutz is one of the most celebrated female war heroes of World War II. As a first lieutenant army flight nurse, she participated in 196 missions, evacuating over 3,500 men. She also logged the most flight hours of any flight nurse. She earned six battle stars before her death and was recorded as the first military woman to die in a combat zone in World War II. Lutz was awarded the Air Medal four times, the Oak Leaf Cluster, the Red Cross Medal and the Purple Heart. She was also the first woman awarded the Distinguished Flying Cross in a world war, our nation's highest military honor.

Aleda Lutz, the military's most decorated Michigan woman, was a World War II air transport nurse and was killed in a plane crash. *Michigan Women's Hall of Fame.*

"For outstanding proficiency and selfless devotion to duty," reads the citation accompanying the Distinguished Flying Cross posthumously presented in December 1944 to First Lieutenant Aleda E. Lutz of Freeland. She had volunteered for duty with the 802nd Medical Air Evacuation Squadron, the first of its kind. Lutz had recorded 814 hours in the air when the pilot lost control of the C-47 hospital plane he was flying. Along with Lutz, the pilot and crew, fifteen wounded soldiers from the battlefront near Lyons in France were killed in the crash, making her the first woman killed in action in World War II.

A veteran's medical facility located in her hometown of Saginaw was named after her by congressional decree. The congressional resolution was first offered in 1949 but died in committee, mainly because she was a woman. Though the building was completed in 1950, it was not until August 15, 1990, that it was officially named. A United States Army hospital ship and a C-47 plane have also been named in her honor. These honors make Lutz the second highest decorated woman in the history of the United States military. The first was Civil War doctor Mary Walker.

Bernice "B" Steadman

Bernice Steadman always knew she would fly. After graduating from high school during World War II, Steadman took a job as an inspector at Flint's A.C. Sparkplug factory to pay for flight lessons. The lessons paid off, and in 1945, she qualified for her private pilot's license even before receiving her driver's license. Steadman then became a flight instructor and later operated a flight school, a charter service and Fixed Base Operation at Flint's Bishop Airport. After World War II, B instructed Tenth Air Force officers.

She loved racing her aircraft and competed whenever she could. She won the All-Women's Transcontinental Air Race and the All-Women's International Air Race to Cuba in 1955.

In 1961, B Steadman had the honor of being chosen as one of the first thirteen women, the Mercury 13, to qualify as American astronauts. She was not, however, allowed to participate in a space mission. To her everlasting disappointment, the Women in Space program was cancelled before any of the Mercury 13 were airborne. Even so, she endured and successfully passed the psychological and physical tests given to male astronauts. Those thirteen women also changed the course of women in aviation. Lieutenant Colonel Eileen Collins, U.S. Air Force, the first woman to command a space shuttle, said, "I didn't get here alone. If the Mercury Thirteen had failed, it would have been a different story for me." Steadman, with the assistance of Jody Clark, captured her story of that important time in history in *Tethered Mercury: A Pilot's Memoir: The Right Stuff, the Wrong Sex.*

Until her death in 2015, Steadman retained her Airline Transport License, the FAA's highest rating. Her career flying hours total over sixteen thousand. She was the co-founder, past president and chair of the board of trustees of the International Women's Air and Space Museum in Cleveland, Ohio. She served as a charter member of the Federal Aviation Agency's Advisory Committee on Aviation and as chair of the Airport Commission in Ann Arbor.

In 2002, Bernice Steadman was inducted into the Michigan Aviation Hall of Fame. She followed that with induction into the Michigan Women's Hall of Fame for her "remarkable spirit, her determination, and, most importantly, for the advances she has made for women."

GIRLS JUST WANT TO HAVE FUN

I never thought I'd see the days when girls would get
sunburned in the places they do today.
—Will Rogers (1879–1935)

That observation was made by a man who died in 1935. What would he think today? It's safe to say we are now able to tan in places he never imagined, up to and including full-body tans made possible by tanning beds, high fences and nude beaches. Not to mention that those fully tanned bodies are sometimes almost totally exposed by exotic dancers in strip clubs.

HARRIET QUIMBY

Harriet Quimby of Arcadia Township flew for a little less than a year, but that was long enough to make aviation history. Never mind Michigan— she was the first woman in the country and the second in the world to earn a pilot's license. She was the first woman to fly over the English Channel. If that wouldn't have been enough to secure her place in history, she became a racer.

A gifted journalist with a deep love of the theater, she first made a name for herself as a writer at *Leslie's Illustrated Weekly*. In 1910, she accepted an assignment to cover the Belmont Park International Aviation Tournament.

She befriended John Moisant and convinced him to take her on as a student, even though the Wright brothers insisted women did not belong in the air. Less than a month after earning the thirty-seventh license in American aviation history, she won her first cross-county race.

Quimby began touring with the Moisant International Aviators and performing at flying exhibitions. Instinctively understanding the power of publicity, she always flew in her trademark costume: a dramatic purple satin flying suit and hood. She kept her adoring fans entertained by writing about

Left: The Detroit Women Painters celebrating their exhibition at the Holt Gallery in New York. *Bentley Historical Library*.

Below: These women are dressing in 1880s fashion to impersonate the founders of the Women's Home Missionary Society of the Methodist Episcopal Church. *Grand Rapids Public Library*.

her adventures in articles for *Leslie's*. Quimby took her writing to another level and wrote seven short scripts for silent movies and even appeared in one of them.

On April 16, 1912, the day after the *Titanic* sunk, she departed for Dover, England, in a borrowed plane that she had never flown before and with no instruments except a compass she had just learned to use. Despite poor visibility and fog, she landed fifty-nine minutes later in Hardelot, France. She survived that close call, but three months later, Harriet Quimby fell to her death when she lost control of her plane.

Chapter 3 talks about women who held certain causes close to their hearts and often organized clubs and ad hoc committees to make positive changes in both their local communities and the world at large. But not all women's clubs were organized for the sole purpose of social reform. Some were to socialize with other women who shared their passions. Those passions included hobbies, sports and religious affiliations. Others, like the Red Hat Society, were all all about getting together and having fun.

The Roaring Twenties. Flappers. Bobbed hair, short chemise dresses showing (gasp!) not only knees but the arrow-straight seams in their stockings. And this was but a short time after the title song from the Broadway musical *Anything Goes* told us that "in olden days a glimpse of stocking was seen as something shocking." They drank bathtub gin and danced the Charleston while "wishing they could shimmy like their sister, Kate." Their shenanigans left little doubt that womanhood was indeed aboard that proverbial handbasket headed you-know-where.

Time has tamed the spectacle they made of themselves. Though bobbed, their hair was never green or purple. Their midsections remained under cover, and even if they had been exposed, they probably sported no navel rings. And those eyebrow-raising dances never suggested a second immaculate conception. Tattoos? Only for those seeking careers as circus sideshow attractions. Sideshow was the polite term; most referred to them as freak shows.

Even so, the style evoked a party girl image, and party girls were not considered appropriate candidates for employment, especially as teachers. One clever twenty-year-old with a newly minted teaching certificate said she got around the issue by lowering her skirt. While that announcement was met with raised eyebrows and raucous laughter, she quickly explained that all she meant was that she wore it longer.

Sometimes, no one cared at what length a young lady wore her skirt as long as her behavior was exemplary. Charles McKenny, president of the Michigan State Normal College at Ypsilanti (now Eastern Michigan University), said he saw no harm in short skirts and short hair. McKenny was even quoted as saying, "Bobbed hair, short skirts, and red cheeks go together," and completed his speech by disagreeing with those who subscribed to the handbasket theory with his opinion that the world was not growing worse: "It is in the process of growing better all the time."

For McKenny, the deal-breaker was smoking, not style, and he expelled a student for her alleged tobacco habit, though she explained she had smoked only three times ever and that the cigarettes and ashes found in her room had been used only to burn the edges of photographs that she used as décor on her walls. The low-budget art did indeed grace her walls, but she was not given the benefit of the doubt. Not only was her expulsion upheld, but she was also told she would not be welcome to enroll the next semester. Normal schools like the one in Ypsilanti existed for the purpose of training young women to teach. Like Caesar's wife, teachers were required to be above reproach.

Julia Moore

Back in the dark ages before we found our entertainment on smartphones, poetry was not only a respected art form, but poets were revered. John Greenleaf Whittier, Walt Whitman, Eugene Field and others gave readings in sold-out halls for people who truly appreciated them.

Kent County resident Julia Moore, known as the Sweet Singer of Michigan, was definitely not among the revered. She didn't sing, and there was nothing sweet about her work. Though she referred to her verse as songs, unless one's musical taste ran to funeral dirges, they hardly qualified. Julia focused on death and suffering, especially if those who died and suffered were children. It was said she gleaned her material from community tragedies, and when that proved insufficient, she turned to the obituaries. She is best remembered for a collection of her poems called *The Sentimental Song Book*.

Moore was born in Plainfield in 1847 and grew up in Algoma. Her mother was an invalid, thus giving her an up-close and personal look at suffering. Upon her marriage to Fred Moore, Julia moved to his farm in Edgerton. The couple later settled in Manton, where, in addition to farming, Fred operated and owned a sawmill.

In her readings, she was never content to let her work stand on its own. In what might be called a forerunner of the canned laughter now heard on TV sitcoms, she punctuated her performances with occasional outbursts of weeping and wailing and, dare we say it, gnashing of teeth. When she gained a national following among luminaries including Mark Twain and Eugene Field, she believed she had reached a level of success sought by many and found by few. Field went so far as to say while in London, "I have been wishing that these English critics could get hold of the inspired poems by the Sweet Singer of Michigan. What fun they would have!"

Someone else said could Shakespeare read her work, he'd be glad he was dead. That was saying a lot, as the Bard knew a thing or two about suffering. Twain parodied her in *Huckleberry Finn* when his fictional Emmeline Grangerford wrote a Julia-style ode to Stephen Dowling Butts.

Master of doggerel Ogden Nash claimed she was where he found his way to the humorous works for which he was famous. His daughter introduced him to Julia's work and convinced him he could make his mark as a good bad poet better than as a mediocre good poet. One reviewer described some of Julia's poems as "so bad, that they were really works of art."

In a similar vein, Van Allen Bradley, literary editor of the *Chicago Daily News*, reported in 1959 that Moore's book had become a collector's item. He further explained, "The collector's item is almost always a book of some merit. But the strangest of all, perhaps, is the absolutely terrible work of Julia Moore. It was so bad that collectors prize it. So bad, in fact, that it was good."

Bradley reasoned that had the Sweet Singer been mediocre or simply bad, she would have been overlooked. But her efforts were too awful to ignore; thus, decades after her death, she was still being written about. Her critics, though unkind, were not inaccurate, as demonstrated in the following example:

> *One morning in April, a short time ago,*
> *Libbie was alive and gay;*
> *Her Savior called her, she had to go,*
> *Ere the close of that pleasant day.*
> *While eating dinner, this dear little child*
> *Was choked on a piece of beef.*
> *Doctors came, tried their skill awhile,*
> *But none could give relief.*

For a time, Moore never suspected her so-called fans saw her as an object of ridicule and found her heartfelt work hilarious in the extreme. She finally caught on when she performed to a standing-room-only crowd at the Powers Opera House in Grand Rapids. In the middle of a particularly melodramatic rendering of pain and suffering, her audience exploded in laughter. Moore had the last word. Standing up straight, she told the crowd, "You each paid twenty-five cents tonight to see one fool. I was given seventy-five dollars to see a hall full of fools." Go Julia!

After that fiasco, Fred made her promise to end her career. She kept her word and refrained from writing until after his death, when she no longer felt bound. Moore's maudlin poems even spawned a Julia Moore Poetry Festival, an annual competition for the best bad poetry in her style. Poets (if you can call them that) from around the country bring forth their best worst efforts, and even her descendants have been known to compete. Her great-great-great-granddaughter presided over the awards ceremonies one year.

Annie Edson Taylor

While the term "extreme sports" may be new to the lexicon, the concept itself has been around for as long as there have been daredevils seeking new thrills. Along with the likes of Evel Knievel, there have been adventure-seeking women who also constantly pushed boundaries. What could be more extreme than riding over Niagara Falls in a barrel? And who could be wilder than the first person to survive the trip?

Her name was Annie Edson Taylor, and though she was born in Auburn, New York, she called Bay City, Michigan, home. That's where she had relocated and opened a dance school at the time of her death-defying joyride.

Taylor traveled to the U.S. side of the falls at Goat Island, New York, on October 24, 1901, her sixty-third birthday. After a short ride in a rowboat, she climbed into a barrel named the Queen of the Mist. Her barrel was a custom-made pickle barrel measuring five feet high by three feet in diameter and weighing 160 pounds. It was lined with a thin mattress and had straps to hold her in place. Taylor wore a long black dress, a flower-bedecked black hat and most likely a corset. She was nailed in, and then, using a bicycle pump, her friends compressed the air in the barrel to thirty pounds per square inch. Then, showtime!

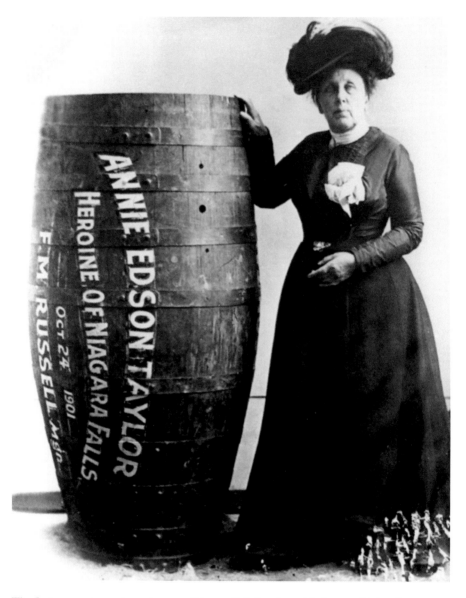

The first person to survive going over Niagara Falls in a barrel is shown with her famous barrel. *Wikimedia.*

While she held tight to her good luck charm, a heart-shaped pillow, her barrel hurtled over Horseshoe Falls on the Canadian side. It took only twenty minutes to careen down the 167-foot cataract. The average October water temperature was in the mid-fifties Fahrenheit. Taylor emerged unscathed

except for a small gash on her head. It would appear she didn't enjoy the ride. She told the press, "If it was with my dying breath, I would caution anyone against attempting this feat. I would sooner walk up to the mouth of a cannon, knowing it was going to blow me to pieces than make another trip over the Fall."

After the stunt, she posed beside the barrel while a cat perched on top. That was her cat, which survived a test ride over the falls before Annie herself did the deed. By all accounts, she didn't have a death wish, only a mile-wide wild streak that demanded challenges far outside the proverbial box. Also, the widowed schoolteacher expected to cash in on the experience. That never happened, and she died in poverty on April 29, 1929.

Sippie Wallace

Legendary blues singer Sippie Wallace was born in Jefferson County, Arkansas, in 1888, the fourth of thirteen children. Her birth name was Beulah Belle Thomas, but she was given the nickname Sippie because of the sound she made while drinking milk. The Thomases were a musical family, and Sippie later played with her older brother George and younger brother Hersal. She grew up in Houston, Texas, where she sang and played piano at Shiloh Baptist Church.

The fact that they performed in a church didn't stop some of the Thomas siblings from sneaking out to watch the black burlesque traveling tent shows that rolled into town. During her teens, Wallace was performing in those shows, often writing the songs she sang. Her reputation grew, and she had a huge following during the blues and jazz craze of the 1920s. She became known as the Texas Nightingale. When she moved to New Orleans, she became a sensation there as well and often performed with the likes of Louis Armstrong, Johnny Dodds and Clarence Williams.

Wallace's musical gift was her ability to elevate the sorrows of the human condition to song. She wrote and sang about poverty, misplaced love, death and loss in ways that resonated with all who heard her. One reviewer called her style "earthy and self-assertive." Her music was once described as "the most sobbin'est, weepin'est, moanin'est blues you ever heard." She soon was performing in venues across the country and beyond.

Her first marriage, to Frank Seals, ended in divorce. Then she met and married Matt Wallace, with whom she moved to Detroit in 1929. At first she

performed frequently in cabarets and nightclubs, but it wasn't long before those gigs stopped coming. The Great Depression hit the music industry hard, and even top names like Sippie Wallace struggled. Her personal life unraveled too. Within a couple of years, she lost the four people she loved most. Her sister Lillie died, her brother Hersal died of food poisoning and her brother George died when he was hit by a Chicago streetcar. Then, the worst—her beloved husband, Matt, died of pneumonia.

Wallace found comfort in making music where she had started: in church. This time it was the Leland Baptist Church in Detroit. She worked as organist, soloist and choir director. Eventually, she became the director of the National Convention of Gospel Choirs and Choruses. During that time, she also worked as a nurse to supplement her income and occasionally accepted invitations to perform secular music. She had no children of her own but became mother to her niece's three orphaned children. Her niece Hocel had also been a blues singer.

Fast-forward to 1966, when Wallace was convinced to make a comeback. After all those years, there was still a place in the industry for this blues great. She performed with other big names like her old friend Louis Armstrong and made new ones, most notably Bonnie Raitt, with whom she went on tour. Sippie Wallace was once again living the life for which she was destined.

She suffered a stroke but recovered sufficiently to resume her career. Then, in 1986, while touring in Germany, she was felled by a second stroke at the Burghausen Jazz Festival. She returned home to Detroit, where she died at the Sinai Hospital on her eighty-eighth birthday.

RUTH VAN DYKE UNGER

Try growing up on a Michigan fruit farm as the fourth child and only girl of seven siblings. As Carl Unger tells it, his mom worked hard with her brothers, and she played even harder. She especially liked baseball, and because the boys cut her no slack, she became a good player—good enough that she wanted to go to St. Joseph and play with the women's Israel House of David team. Naturally her parents forbade it, but as Carl says, "Mom was tough as nails and went anyway."

This was decades before the women's professional league during World War II that was made famous in the film *A League of Their Own*, and Unger simply longed to play the sport she loved. She didn't make the team on

The popular Grand Rapids Chicks of the All-American Girls' Professional Baseball League are playing against the Kalamazoo Lassies. *Grand Rapids Public Library.*

A few of the men on a House of David men's baseball team that hired both Babe Didrikson and Jackie Mitchell to play with them. *Benton Harbor Library.*

her first tryout and found the lifestyle of the sect restrictive in the extreme. They lived in a commune where they abstained from meat, alcohol, tobacco, the cutting of hair and sex. The last no-no leads to the question of how they intended to combat attrition, and the answer lies in the tenets of their faith. Unlike other Christian denominations teaching the eternal life of the soul, the members believed the body would live forever as well. It's uncertain how they justified the pleasures offered at the resort with the way they lived themselves.

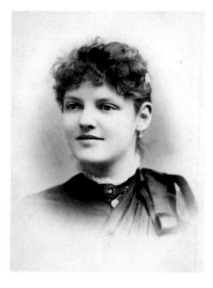

Ruth Van Dyke Unger left the farm to play baseball at the House of David and ended up owning a business in Chicago. *Rodney Unger.*

Rather than go home and admit she had made a mistake, Unger went on to Chicago, where she lived with an aunt and found work in a local restaurant that she bought following the owner's death. Along the way, she married Thomas Unger and had three children, Thomas Jr., Carl and Sandra.

And that team she didn't get to first base with? Turns out five of the players were actually men who dressed as women to play. No wonder the "ladies" never lost when playing legitimate women's teams. Why would a strict religious community allow such deception? Good question. The Israel House of David was a religious compound that made obscene amounts of money operating an enormously popular resort but was best known for its men's baseball teams. The players sported beards and long, often-braided hair. They barnstormed around the country playing Negro League teams and other semi-pro clubs, along with exhibition games with major-league teams.

The Davids occasionally employed female players, the most famous being the legendary Babe Didrikson. Another young lady who played for the House of David men's team had begun her career in Chattanooga, Tennessee, with the Chattanooga Lookouts. Her name was Virne Beatrice "Jackie" Mitchell, and she was a pitcher. Her dad had taught her to play the game, and when she was only eight years old, Brooklyn Dodgers pitcher and family friend Dazzy Vance taught her how to pitch.

Mary Purnell was the wife of Israel House of David founder Benjamin Purnell and led one of the factions following his death. *Benton Harbor Library.*

Dazzy and her dad convinced Mitchell that she could throw a ball as hard and as fast and as far and as well as any man. During one exhibition game against the New York Yankees, in front of a crowd of more than four thousand, this unknown seventeen-year-old girl struck out Babe Ruth and Lou Gehrig in only seven pitches. In four pitches, the Bambino was out, and

she dispatched the Iron Horse, Gehrig, one-two-three. In another game, she struck out Leo Durocher of the St. Louis Cardinals.

Gehrig and Ruth graciously posed for a picture with Mitchell, but just a few days later, baseball commissioner Lou Landis voided her contract. He said women didn't belong in baseball, as the game was too strenuous. Hmm…maybe it was simply too embarrassing. Don't tell Babe Didrikson, Jackie Mitchell or even Ruth Unger that baseball was no game for girls. Mitchell went on to play for the House of David for six years, pitching in exhibition games, before returning home to Chattanooga, Tennessee. She had dreamed of someday pitching in the World Series but had to accept the fact that that would never happen.

Another wild woman associated with the Israelite House of David was Mary Purnell. Mary and her husband, Ben, started the sect, and when he died in 1927, it went up for grabs. Mary was one of the grabbers, and she took control of half of the group. The split was caused by theological differences, and about half followed Thomas Dewhirst and kept the original name. The others chose to follow Mary and her Israelite House of David as Reorganized by Mary Purnell. She was so revered that she was often referred to as Queen Mary. Mary Purnell lived to be ninety and died in Benton Harbor on August 19, 1953.

Babe Didrikson and Jackie Mitchell blazed a trail in baseball for girls like twelve-year-old Carolyn King of Ypsilanti. During the 1977 Little League tryouts, Carolyn outperformed three boys for a position on the Ypsilanti Orioles, making her the first girl to play on one of the national organization's teams. That prompted the league to revoke the city's charter. Ypsilanti initiated a sex discrimination lawsuit, but before the litigation began, the federal Division of Civil Rights forced the league to abolish its boys-only rules.

Why is it that in earlier days, men competed in various rough-and-tumble ball games for enjoyment while women were confined to the more ladylike contests of badminton or croquet? Fortunately, there were women like curling enthusiasts to knock down yet another chauvinist wall. Winter was, and still is, a harsh Michigan reality, and there's nothing like a curling bonspiel to get the blood flowing. The game is rooted in medieval Scotland, and the Scots also know a thing or two about harsh weather. Certainly the game was more challenging than donning those skates and simply dancing around the ice, often while leaning on a male partner for support.

As an ever-increasing number of women became college students, women's athletic teams became the norm. In addition to the more popular sports like softball and basketball, golf and fencing teams emerged.

Leaving the safety of the earth under their feet takes a bit of courage today and took a boatload of it back in 1892. Gertrude Carmo became the first Michigan woman to go up, up and away in a hot air balloon. She died of injuries suffered when the craft crashed at the Detroit Exposition grounds, making her unable to describe what must have been an awesome experience right up until the tragic ending.

Alice Eckardt of Mount Morris Township became a certifiable wild woman and proved her right to the designation when in August 1982 the then-seventy-year-old went sky-diving for the first time and jumped three thousand feet from a single-prop aircraft. Makes one wonder what else was on her bucket list.

It must have been difficult playing in these University of Michigan 1903 basketball uniforms compared with today's shorts and tank tops. *Bentley Library, University of Michigan.*

Detroiter Jeanne Omelenchuk wasn't content to excel in a single sport; she earned a place on three Olympic speed skating teams, and in addition to winning national championships in speed skating, she won one in bicycle racing as well. She was still going strong at age sixty when she won the Great Lakes Masters title. Perhaps the competitive spirit that drives athletes is what also led her to politics in 1985. Jeanne served as mayor pro tem and president of the Warren City Council. She attributed her many successes to constant perseverance.

No one would have called wrestling an extreme sport in 1992, and female wrestlers were no longer considered bold. Even so, a case could be made that Lauren Wolfe of Okemos was both bold and extreme. In that year, she became the first girl on the winning high school wrestling team when the Michigan High School Athletic Association rules stated that because her school lacked a girls' team, and apparently there were no other girls interested in forming one, she was eligible to wrestle on the boys' team. During her high school years, Lauren earned four varsity letters in the sport and later won the national women's tournament and represented the United States in the world freestyle championships in Moscow. While there is nothing on record to prove it, it's a safe bet that when in high school, any boys she dated took her word for it when she said no, and she didn't have to ward off any attempts to engage her in the back-seat Chevy Cha-Cha-Cha.

Another wrestler, Tricia Saunders of Ann Arbor, also began the sport with male opponents. She was nine when she began, and she often won matches against boys. Saunders has been called "the grand dame of women's wrestling," as she continued beyond school and won eleven United States Women's Freestyle Championships. Following that, she was named the U.S. Olympic Committee Women's Wrestler of the Year not just once, but three times. When her competing days were over, she launched a coaching career that included, in 2004, coaching the country's team for the first Olympics Games where women's wrestling was an event.

JULIE KRONE

Julie Krone grew up in Benton Harbor and was riding her pony on her own track by the time she was five. She turned that early love of all things horsey into becoming a groundbreaking jockey, a decision she made at age fourteen while watching the Belmont Stakes on television. If anyone could make

Professional jockey Julie Krone rode her first mount, a pony, at home in Michigan. *Photo by Bill Mochon. National Museum of Racing and Hall of Fame.*

this happen, it was Krone, who was described as a fierce, fearless daredevil who had previously considered a circus career, performing gymnastics on horseback.

Her male competitors didn't always welcome her and sometimes combined forces to block her in. Some went so far as to "accidentally" hit her with a whip or physically hurt her in other ways. They soon learned that she might be only four feet, ten inches, but Krone wasn't afraid to fight back. She gave as good as she received to the extent that she was once fined for brawling.

At Meadowlands in 1988, she was the only jockey, man or woman, to win six races in one day. In 1991, and again in 1992, she won Triple Crown events riding Colonial Affair. A year later, at Saratoga, she became the first woman to win five races in a single day. But just when everything was going exactly as she wished, she had a serious accident.

For anyone else, it could have been a career ender when her horse fell and trampled her. Along with other injuries, she suffered a shattered ankle. Down, but not out, Krone underwent two surgeries and spent nearly a year recuperating before "getting back on the horse," as the saying goes. It's easy to imagine her heart pounding with joy and perhaps a modicum of fear the first time she mounted a horse and entered the starting gate to return to the sport she loved.

To say Krone focused on her career is an understatement, and some may have questioned her priorities on August 26, 1995. That's the day Julie rode in six Saratoga races before changing into bridal attire for her evening wedding to Matthew Muzikar. But, hey, if the groom didn't object, who are we to raise eyebrows?

In 1993, Krone and basketball great Sheryl Swoopes were named Sportswomen of the Year by the Women's Sports Foundation. Krone is also an inductee in the Michigan Women's Hall of Fame and Thoroughbred Racing Hall of Fame.

She retired, sort of, in 1999. Though she wasn't racing, she worked as a race broadcaster. But Krone soon realized that wasn't enough and she really wasn't ready to give up competing. Her return was easy. She won regularly and even made history as the first female jockey to win a Breeder's Cup when she won the event at Santa Anita. Everything seemed to going her way when she had another accident.

In December 2003, just weeks after her thrilling Breeder's Cup win, she fell from her mount, Halfbridled, at the Hollywood Park racetrack. This time, she fractured some ribs, but her worst injury was severe muscle tears. Though she attempted a comeback, it was not to be, and though she never said never, she has yet to race again.

Julie Krone's first marriage ended in divorce after four years. She married Jay Hovdey in 2001, and they have a daughter, Lorelei Judith. Today, she keeps busy with her daughter and race broadcasting. She is a popular speaker on the motivational speaking circuit and teaches horsemanship.

Most women—and men too, for that matter—might not consider circumnavigating Lake Superior in a sixteen-foot catamaran fun. The world's largest and most dangerous lake has seen more than its share of shipwrecks, one of the most famous being the *Edmund Fitzgerald*. That begs the question, what chance would a sixteen-foot open sailboat have?

Eighteen-year-old Naomi Behrend and her father, Carl, decided to find out. Naomi kept a journal, and her postings describe a voyage of about a month's worth of frightening stretches of billowing waves punctuated by hours of sheer terror. One thing that stands out is the incredibly strong bond between father and daughter and their trust in God to bless their travels. He obviously did, as they came out of it alive.

Lorleen Niewenhuis

What is it about a lake that compels people to circle it? One popular road trip for Michiganders and travelers in general is the Lake Michigan Circle Tour. The route is easy to follow, and by following it, one sees an abundance of lighthouses, charming beach towns and other attractions in Michigan, Wisconsin, Illinois and Indiana.

Like Naomi Behrend, Lorleen Niewenhuis knew she had to go around a lake. In her case, it was her beloved Lake Michigan, not the wilder Superior. Niewenhuis didn't settle for driving or even sailing the perimeter; she needed to get up close and personal on foot. The Battle Creek resident began her one-thousand-mile trek at Chicago's Navy Pier on March 16, 2009, and hiked counterclockwise. Her rationale was simple: she wanted to get the industrial portion of eastern Illinois and western Indiana over with first so she could enjoy the remainder.

Niewenhuis's adventure was born of a need to spend time alone in nature. Her sons were in college and high school, making her an almost empty nester, so what better time to embark upon a sort of Vision Quest or beach version of an Australian walkabout. Like those who drive around Lake Michigan, she visited lighthouses and quaint towns and sampled local culinary specialties like pasties, smoked whitefish and that unforgettable fudge on Mackinac Island, where the treat is so prevalent the locals call tourists "fudgies."

Unlike the drivers who experience much of the trip from their windshields, Niewenhuis made it a point to learn about the lake's pollution, its invasive species of fish and endangered species of wildlife along its shores. Sometimes family members or friends joined her for a day or two, though she estimates she hiked alone about 80 percent of the time. Strangers invited her for lunch, and reporters interviewed her. This was not strictly an outdoor adventure. She camped only a few nights and, between stretches of hiking, relaxed for a few days in a hotel or even went home. In spite of that, she hiked every mile of the lake. If bad weather prevented her from covering a portion, she went back to it later, usually compliments of her brother, who was her principal transporter.

On September 29, 2009, Niewenhuis ended her walk on the beach where she had started, at Navy Pier, only this time surrounded by family and friends, some of whom had walked with her on portions of the journey and wanted to be part of its completion. She was twenty pounds lighter and brimming with confidence. More important, she had a greater understanding of the lake she had loved her whole life and the challenges it faced.

SUELLEN FINATRI

Suellen Finatri of Moorestown, near Higgins Lake in Roscommon County, rode horseback more than four thousand miles from St. Ignace to Skagway, Alaska, in 1995. She is believed to be the first and only person to accomplish this feat. Maybe the real question is who else would want to? Her ride started on February 1, and she arrived in Skagway on November 30. Yes, that meant for several months her horse, Nakota, pranced through some of North America's harshest weather. Accompanying the forty-four-year-old mother of three and grandmother of three was her black lab, Cheyenne.

Along the way, she faced blinding storms, extreme cold, several wolf packs, isolated terrain and the Canadian Rockies. From St. Ignace, Finatri rode west through Michigan's Upper Peninsula, Wisconsin, Minnesota and North Dakota before entering Canada and the provinces of Alberta, Saskatchewan, British Columbia and the Yukon. Her original plan had been to ride to Whitehorse in the Yukon, but when temperatures dipped to sixty below, she went the shorter distance to Skagway instead.

Finatri was no stranger to pushing her endurance beyond most people's comfort zones; she had worked as a long-distance trucker. Always an outdoorswoman, she stretched herself further by living alone for a time on the remote Sugar Island. Both experiences toughened her for this latest adventure.

Her journey was publicized to the extent that several small-town mayors came out to welcome her as she passed through. In interviews after the ride, she said she was ever-amazed at the kindness of people she met along the way. Canadian Mounties checked on her from time to time, and one man she met on the Alaska Highway in Canada offered her the key to his house in Whitehorse. He was heading south for the winter and said he wouldn't be needing it until spring.

She relocated to Wyoming, where she still enjoys long-distance horseback riding.

Miss America 1961
Nancy Anne Fleming
MONTAGUE, MICHIGAN

Nancy Anne Fleming put Montague on the map when she was crowned Miss America in 1961. *Author's collection.*

Fun is where you find it. Some people today find beauty contests degrading. That said, there's still a lot of prestige, not to mention scholarship money, in being crowned Miss America. Back in 1961, when Nancy Ann Fleming of Montague reigned, it was a major accomplishment.

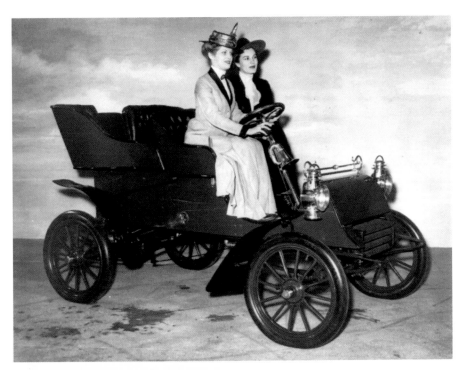

Above: Two pretty women demonstrate how much fun a Ford can be during the Automotive Industry Golden Jubilee in 1946. *Library of Congress.*

Left: Kay Davis, shown dancing while wearing the clichéd lampshade, is actually dressed as Miss IES (Illuminating Engineers Society) in 1939. *Grand Rapids Public Library.*

The young lady dressed as a lamp looks wild indeed, but the image wasn't taken at a party or a club. She was working at an electrical association trade show, as were the ladies in the car. What better way to showcase a car and automotive show than by having two lovely young women show how much fun it would be to own one?

THEY DIDN'T JUST BREAK THE LAW, THEY SMASHED IT INTO ITTY BITTY PIECES

There was a little girl
who had a little curl,
right in the middle of her forehead.
When she was good
she was very, very good,
but when she was bad she was horrid.
—Mother Goose

In the mid-1800s, charlatans hawked so-called medicines guaranteed to cure whatever ailed anyone. Curiously, these were often the same potion. Women like Mary Squires got in on the act. Squires claimed to be a medium and said her cures were revealed to her by the spirit world.

Some of the mediums were scam artists. For most, it was nothing more than good fun and showmanship. Fortune-telling became a popular event at fairs and other mass events. Tearoom owners brought in tea-leaf readers as an added element of entertainment for the hatted and white-gloved ladies who lunched. Less benign was the woman who billed herself as an electrocutrix and administered small amounts of electricity in a cure that sounds worse than the diseases she claimed required it.

Michigan's only monarch, self-appointed King Jesse Strang, was also a Mormon leader, again self-appointed, and imposed strict rules in his Beaver Island kingdom. His initial popularity declined when he ordered non-Mormon islanders to join his flock or leave. He practiced but preached

against polygamy. His flock grew disenchanted, especially the women who resisted his order to wear King of Siam–like short tops over longer pants in an attempt to save money. The irate ladies complained to their already fed-up husbands, and the Bloomer Rebellion became a factor in the dethroning of King Strang via assassination.

"Bloomers" were undergarments resembling the pants King Strang insisted the Beaver Island women wear. They received their name from women's rights advocate Amelia Bloomer, who regularly wore them. Strang chose them because they required a smaller amount of fabric than the typical dress of the day and thereby lowered expenses. Two of the women who rebelled were Mrs. Hezekiah McCullough and Mrs. Thomas Bedford, both of whose husbands were already Strang's detractors.

According to Strang, *The Book of the Law of the Lord* dictated that women "shall not clothe yourselves after the manner of the follies of other men but after the manner that is seemly and convenient." The monarch also believed "garments which pinch or compress the body or limbs are objectionable because they injure health, shorten life, and produce hereditary diseases and weaknesses." Who knew?

Prostitution is sometimes called the victimless crime, the rationale being that the "girls" chose their profession and their johns are willing participants. In truth, the girls themselves are usually victims at the mercy of pimps who totally control them and steal the lion's share of the ill-gained profits. In the old days, the pimp was a woman, the madam of the house of ill repute out of which her girls worked.

Sometimes the ladies of the evening freelanced. One of the more infamous used her profession as a cover for her other criminal activity. She collected her fees and then got her clients drunk and stole the rest of their money. Though that forced them to leave broke as well as unsatisfied, her victims had little recourse when robbed while trying to commit an illegal act. She also knew they would be unlikely to complain due to the resulting publicity that would destroy their families and their standing in the community.

The perp of this account was known as Chicago May. Though Ireland born, she plied her trade across the United States, a journey that included firsthand knowledge of the inside of more than one slammer. She eventually landed in Chicago, where she had a long and lucrative career before being forced to flee to Michigan just ahead of the sheriff, as the saying goes. She set up shop in Detroit and remained in business until age rendered her body unsalable.

One Grand Rapids soiled dove proved conclusively that, however difficult, it is possible to leave the business and go on to live an inspirational life. Her name was Georgie Young, and in the 1880s, she was considered one of the best in the city and ran a high-end house of ill repute. Then, in 1887, Young saw the error of her ways. She repented and, in an amazing 180-degree turn, devoted her life to religion. Toward that end, she bought and renovated a house on Waterloo Street that she named the Emerson and turned it into a refuge for "working girls" seeking to leave the lucrative, albeit dangerous, world of prostitution. Area ministers held religion classes for the ladies and counseled them as they worked on turning their lives around. Donations funded the work, along with proceeds from Georgie's autobiography, *A Magdalene's Life*, and the Emerson became a model for such homes in other cities.

Mary Carroll of Lansing was not a woman anyone would have considered maternal; she was, after all, a prostitute and a successful one who was the madam of her own house. The protective gene kicked in when she unexpectedly became her teenaged niece's legal guardian. Despite her own laundry list of sins, or maybe because of it, Carroll took the job of raising her niece seriously. She was off-limits, and any young man who tried to seduce her found himself on the receiving end of Carroll's unrestrained wrath. "I'm raising that girl to be a Christian, danged if I ain't!" she proclaimed in a voice that brooked no argument. Few would-be suitors tried more than once.

Sometimes that whole "for as long as we both shall live" thing seems a little too long to wait, and the only way to take a new spouse is to off the first one. Divorce wasn't as commonplace as it is now, and it bore a stigma. Widows, on the other hand, were seen as vulnerable and brought out a man's protective instinct. Bess Hopkins didn't kill her husband; she killed her lover's wife so that she might acquire one. Nice try, but it ended badly for her.

ALICE LAWRENCE

Another murder gone awry was that of Holland resident Enos Lawrence. Enos and his wife, Alice, had a rather tumultuous marriage, and he was said to physically abuse his much younger wife. That probably would have gone on unabated had not Alice's brother, Raymond Coates, moved in with the

Lawrence family. Raymond was from Detroit but had come to the eastern part of the state hoping to find work.

Whatever else one might say about Enos, he was a hard worker. He also thought his brother-in-law was lazy and that the laziness was the root of his failure to find or keep a job. Meanwhile, Raymond's anger over Enos's treatment of Alice festered. It's safe to say tensions were rising rapidly in that household.

Then one day, Enos disappeared. When asked, Alice explained that he had moved up north for a better job and she, her two children and Raymond would soon be joining him. The story would probably have been believed had not Enos proved to be as ornery in death as he had been in life. He had the audacity to allow his body to wash up on the bank of the Black River in Holland. Oops.

By the time the body was found, Alice Lawrence, Raymond and the children had moved to Kalkaska. Somewhere between Holland and Kalkaska, they changed their names and got married. In their new home, the happy couple hung their marriage license on the wall for all to see.

They were apprehended and brought to trial, where both were found guilty. Lawrence campaigned for a pardon, explaining that she needed to take care of her children, who no longer had a father. That argument fell on deaf ears, as it only served to remind everyone why those kids were fatherless. It's unknown how long a sentence Lawrence served, but Raymond was released after fourteen years. He promptly moved to Battle Creek with the woman he married as soon as he gained his freedom.

It's anyone's guess as to the true nature of Alice and Raymond's marriage. Were they really in an incestuous relationship, or did they marry and display the license to avoid suspicion and fit seamlessly into the community of stable farm families? No one knows for sure, but it's safe to say their sordid story kept tongues wagging for a very long time in both Holland and Kalkaska.

Martha Beck

Most serial killers are not women, but Martha Beck proved the exception to the rule in a bizarre case that became known as the Lonely Hearts Murders. Martha's tale begins in the Florida Panhandle. There, the three-hunred-pound nurse and superintendent of the Pensacola Crippled Children's Hospital answered a magazine ad for male companionship.

That's how she met Raymond Fernandez, who lived in New York but traveled to Florida to meet Beck. She was instantly smitten, but after a brief sexual fling, Fernandez rejected her, not because of her physical appearance but because she had no money. He went back home. A short time later, the hospital where Beck worked fired her. That freed her to follow Fernandez to New York and eventually convince him that if they couldn't be lovers, they could work as business partners. Rumor had it they kept on being lovers too but never let that interfere with business.

Their business was preying on women who were widowed or alone. Fernandez won their trust and then stole their money and disappeared. Beck figured that by pretending to be his sister, she could win the trust of even more vulnerable women seeking romance. But as the business grew, the logistics of hiding from the long arm of the law became a bit too cumbersome. That was when the women, not Raymond Fernandez and Martha Beck, began disappearing.

The duo moved to Grand Rapids, where Fernandez planned to marry wealthy widow Delphine Downing of the Grand Rapids suburb Wyoming. Fernandez made one mistake and let his fiancée see him without his toupee. Call her shallow, but Delphine changed her mind and broke off the engagement. That was a bad decision on her part, as it meant she had to be killed sooner rather than later.

By then, New York police were in hot pursuit, as they had already tied Fernandez to a Long Island murder. By the end of their two-year crime spree, Fernandez and Beck had killed twenty people, mostly women, but there was also a bit of collateral damage, including Downing's two-year-old daughter, Rainelle. Beck drowned Rainelle because the child's crying annoyed her.

When they were finally caught in Grand Rapids, the two were extradited back to New York, as Michigan was not then a death penalty state. They tried to fake insanity, which probably wouldn't have been too much of a stretch. Beck kissed Fernandez passionately in the courtroom, leaving a huge red lipstick stain on his face. Despite their theatrics, the jury didn't buy it. Both were found guilty and executed. In Beck's last statement, she said, "What difference does it make who is to blame? My story is a love story, but only those tortured with love can understand what I mean."

Martha Beck's tenure as a wild Michigan woman was brief. Had the marriage between Fernandez and Downing taken place, it would have lasted until Downing's money was spent. That said, Martha still had a lasting impact on local history with the release in 2006 of *Lonely Hearts*, a movie

based on the crime. John Travolta played the lead detective on the case, and Jared Leto played Fernandez. Curiously, Salma Hayek was cast as Beck, when chunkier Rosie O'Donnell or Kathy Bates (as she appeared as the deliciously demented fan in Stephen King's thriller *Misery*) would have been more physically believable.

Domestic abuse was an issue way back in the early days of the state's history. Then, as now, it often had the curious effect of causing the victim to turn on anyone who came to her aid. One such quarreling couple ran a grocery store in Grand Rapids. The store offered light lunches, so midday business was usually brisk, in part because the store was considered cleaner than any of the nearby eateries.

The proprietors' verbal altercations were so commonplace that regular patrons seldom even noticed. That all changed one day when the dispute became physical. An entrepreneur from out of town grabbed the husband, thereby ending the fight. Instead of thanking him, the wife grabbed a cheese knife and stabbed her rescuer in the back. Even as he ran, bleeding, out of the building, she gave chase, obviously bent on inflicting a second wound. Then, as now, a spouse believed he or she could physically harm the other, but when an outsider became involved, the couple closed ranks and became allies against the good-intentioned intruder.

Dr. DeCamp, a local doctor lacking proper supplies, stitched up the visitor with a harness needle and linen thread. Unfortunately for the injured man, the doctor also lacked any kind of pain-killing meds. The man recovered and left town, never to be seen again, and lunch business at the grocery boomed, as everyone in town wanted to see both the wild woman and her infamous cheese knife.

MARY PIERCE

Mary Pierce wasn't someone who would readily come to mind when you picture a grandmother. More cantankerous than comforting, she nagged, raged and punished with reckless abandon. True, she was a quarrelsome old biddy, but did that mean someone should kill her? Her youngest daughter, Mary Isora, age thirteen, still lived at home. Mary and her husband, Levi, owned a farm in Tallmadge in Ottawa County.

In the summer of 1895, Mary's seventeen-year-old grandson, George Cheesbro, came to live with the family. Young Mary Isora was the boy's

aunt, and she brought out his protective nature. George grew tired of seeing the girl beaten over what most would consider trivial offenses. It all came to a head one morning when the two Marys clashed because Mary Isora had missed a spot when scrubbing the kitchen floor. When Mary hit her daughter with a cane, George grabbed a poker, hit his grandmother on the head and then strangled her until she was dead.

After the kids had cleaned up the ensuing mess, Mary Isora ran out to the field and told Levi her mother was dead in the kitchen. When asked where George was, she said he had left earlier to go to nearby Berlin, but she had seen a strange man running away from the farm right before she found her mother's body.

George was soon found and questioned. Unfortunately for them, they had not taken time to concoct a believable story, so they contradicted each other to the authorities. George was sentenced to life in prison, but the sentence was reduced to ten years. He died of tuberculosis in 1901, two years before his release date. Mary Isora Pierce became the youngest woman ever convicted in Ottawa County when she was sentenced to remain in jail until she reached the age of twenty-one. She, too, died of tuberculosis while still incarcerated.

Francine Hughes

Though a strong case could be made that some of those hombres needed it, killing them wasn't usually a viable defense. There was, however, one notable exception in 1977. Francine Hughes of Danville had suffered enough. Her ex-husband, James "Mickey," beat her on a regular basis and tried to choke her. That's right, he was her *ex*-husband, but even after she divorced him, he would break into her house and continue the brutal abuse. Why hadn't she left him sooner? It was more difficult back then, and especially difficult for a woman with four children. The babies kept coming. That was one way Mickey controlled his wife. Another was by making her think it was somehow her fault and she deserved the abuse.

Then Mickey suffered severe injuries in an auto accident. Because he had nowhere to go when released from the hospital, Francine relented and agreed that he could stay with her and the children, but only until he recovered. That was Francine's mistake. Mickey made a mistake too: he regained his mobility but refused to leave. In no time at all, he began to beat her almost

every night before passing out drunk. On March 9, 1977, he went too far. In a rage, he punched her and dragged her around by her hair. He didn't like it that she had decided to finish high school, so her burned her books. He threw dishes. He threatened to destroy her car if she didn't have sex with him. Then, it was over.

She couldn't, *wouldn't* take it another minute, and if there was only one solution, so be it. Francine got her sleeping children out of the house while Mickey lay sleeping in an alcohol-induced stupor. Then she poured gasoline under his bed and set the house on fire. She was found not guilty by reason of temporary insanity. Feminists rallied around her and declared the verdict an important victory because it put the issue of spousal abuse and the limited options of the victims in the national spotlight. The case inspired the movie *The Burning Bed*, with Farrah Fawcett playing the role of Francine.

In subsequent cases, other women viewed the abused-wife defense as a get-out-of-jail-free card, but their attempts failed unless they could provide adequate documentation of the abuse in the form of police reports, photographs of injuries sustained or witnesses to the alleged abuse.

That was a double-edged sword. Yes, some women might have leveled false claims, but that didn't take into account situations of women who were legitimately abused but were too intimidated and too terrified of retaliation to seek legal protection. Also, it's common knowledge that restraining orders are often disobeyed. That, along with the fact that victims often had no money and nowhere to go, led to the establishment of shelters where women and their children can find safety while planning a permanent escape.

Mary McKnight

Not all murderous women kill a spouse or lover; sometimes it's another family member. A particularly bizarre case was that of Mary McKnight of Kalkaska. McKnight's brother John Murphy; his wife, Gertrude; and their baby daughter, Ruth, all died within a span of about two weeks. Officials suspected foul play and, after exhuming the bodies, found strychnine in all three. McKnight was arrested and confessed. Sort of. In her confession, printed in the *Cedar Falls Gazette*, she described her actions as only trying to help:

The baby woke up and cried while its mother was gone, and I mixed up a little strychnine in a glass of water and gave a spoonful to the baby. I didn't mean to harm the little thing at all.

When Gertrude came home and found the baby dead, she got awfully nervous. She came to me and said, "Can't you give me something to quiet me?" I said that I would, and I really didn't think it would hurt her if I gave her one of the capsules. She had spasms right after that. I suppose it was the strychnine that killed her. I really didn't mean to hurt her.

Then John seemed to feel so badly about it, so broken up, that I often thought that after Gertie died that it would be better if he were to go too. John was feeling bad one night a couple of weeks after Gertrude died. He came to me and wanted something to quiet him. I had one or two capsules on my dresser, and told him to go get one of them.

I didn't mean to hurt him, but I thought that it would soothe him, and then I thought that it would be best if he were to go anyway. He went to bed and then began having those same spasms. I suppose that was the strychnine working.

Maybe she truly didn't realize she was killing them. But that doesn't explain the deaths of two husbands, two daughters, two nieces and at least three others. Her body count is believed to be as high as eighteen. It was said that Mary McKnight loved attending funerals.

Though most of the mayhem occurred in the Lower Peninsula, the UP was not exempt. A case in point is Josephine Marlowe of Marquette. In 1857, she did the deed like the more famous (or should that be infamous?) Lizzie Borden. Josie Marlowe took an axe and gave her daughter-in-law, Eleanor, an unreported number of whacks. The reason? Marlowe didn't like her and felt compelled to correct what she considered her son's terrible mistake in marrying her.

The "worst of the worst" designation goes to serial killer Aileen Wuornos, born in Rochester and raised in Troy. She gravitated to a life of prostitution, probably lured by what she thought would be easy money. Her defense during her murder trial was that she killed her clients because they abused her. One or two? Maybe. But six? Probably not. Wuornos, a big woman, was thought to have been able to fight back. She did, with a gun. She was found guilty and sentenced to death in Florida. On October 2, 2002, she died via lethal injection. She was forty-six years old.

Not all women in bad marriages were driven to violence. Lois Korsak of Battle Creek had been married nearly thirty years when she divorced. It was an easy road for the feisty Lois, as she had long been forced to be more independent than most housewives of the '50s. Her husband's successful career kept him on the road a good bit of the time. Responsibility for keeping the home fires burning and raising the couple's three children fell on her.

The man of the house, when in residence, was never abusive in any way, but he was a control freak. While Lois didn't exactly find his input charming, she was able to brush it off as a clumsy attempt to make up for his long absences. By the time he retired, the kids were grown and she had launched a career of her own. When hubby wanted her to retire too, she refused.

While she had been able to cope with his controlling nature when he was only around to play lord and master on weekends, it became unbearable when she could no longer look forward to his absences. She had heard about men who arrange the spices alphabetically but thought it was a joke until she found her paprika between the onion salt and parsley flakes. Now she not only had his constant presence, but he had assumed an all-out Me-Tarzan-You-Jane mode to boot. It wasn't long before she woke up one morning thinking, "I can't stand this another minute." Lois spent a month getting her affairs in order and filed for divorce.

Who knows? A good plan made by an independent woman might just be an antidote to murder.

SELECTED BIBLIOGRAPHY

Barber, Sally. *Mysteries and Myths of Michigan*. Oviedo, FL: Globe Pequot Press, 2011.

Barfnect, Gary W. *Michillaneous*. Davison, MI: Friede Publications, 1985.

Behrend, Carl. *Adventure Bound: Father and Daughter Circumnavigate the Greatest Lake in the World*. Munising, MI: Old Country Books and Records, 2003.

Bohnak, Karl. *So Cold a Sky: Upper Michigan Weather Stories*. Negaunee, MI: Cold Sky Publishing, 2006.

Buhk, Tobin T. *True Crime in Michigan: The State's Most Notorious Cases*. Mechanicsburg, PA: Stackpole Books, 2011.

Burns, Virginia. *Bold Women in Michigan History*. Missoula, MT: Mountain Press Publishing Company, 2006.

Comstock, Lyndon. *Annie Clemenc*. Charleston, SC: CreateSpace Publications, 2013.

Ford, R. Clyde. *Heroes and Hero Tales of Michigan*. Milwaukee, WI: E.M. Hale and Company, Publishers, 1930.

Freedman, Eric. *Pioneering Michigan*. Franklin, MI. Altwerger and Mandel Publishing, 1991.

Grimm, Joe. *Michigan Voices: Our State's History in the Words of the People Who Lived It*. Detroit: Detroit Free Press, 1987.

Hammond, Amberrose. *Wicked Ottawa County*. Charleston, SC: The History Press, 2011.

Journal of Beaver Island History. Beaver Island, MI: Beaver Island Historical Society, 1987.

Kestenbaum, Justin L., ed. *A Pioneer Anthology: The Making of Michigan, 1822–1860*. Detroit: Wayne State University Press, 1990.

Ladies of the Lights: Michigan Women in the US Lighthouse Service. Ann Arbor: University of Michigan Press, 2010.

Perkins, Stan. *Lore of Wolverine County*. Swartz Creek, MI: Broadblade Press, 1984.

Majher, Patricia. *Great Girls in Michigan History*. Detroit: Wayne State University Press, 2015.

Motz, Marilyn F. *True Sisterhood: Michigan Women and Their Kin*. Albany: State of New York University, 1984.

Nenadic, Susan B. *A Purse of Her Own: Occupations of Women in the 19th Century*. Ann Arbor, MI: Nicolas Books, 2013.

Ostrander, Stephen Garr, and Martha Aladjem Bloomfield. *The Sweetness of Freedom: Stories of Immigrants*. East Lansing: Michigan State University Press, 2010.

Pferdehirt, Julia. *More than Petticoats: Remarkable Michigan Women*. Guilford, CT: TwoDot, 2007.

Rosentreter, Roger L. *Michigan: A History of Explorers, Entrepreneurs, and Everyday People*. Ann Arbor: University of Michigan Press, 2014.

Stanley, Jerry. *Big Annie of Calumet: A True Story of the Industrial Revolution*. New York: Crown Publishing, 1996.

Troester, Rosalie Riegle, ed. *Historic Women of Michigan*. Lansing: Michigan Women's Studies Association, 1987.

INDEX

ABOUT THE AUTHOR

Norma Lewis has lived in southwest Michigan for more than twenty-seven years. She loves local history and is a member of the Grand Rapids Historical Society, the Greater Grand Rapids Women's History Council and the Tri-Cities Historical Museum in Grand Haven. *Wild Women of Michigan* is her thirteenth book and her seventh with Arcadia/The History Press, three of which she coauthored with her late husband, Jay deVries. She currently lives in Grand Haven with Scalawag, a marmalade cat that more than lives up to his name.

Visit us at
www.historypress.net

··

This title is also available as an e-book